COLOR
your campus

INDIANA
UNIVERSITY

ILLUSTRATED BY

Melissa Mueller

QUARRY BOOKS

an imprint of · Indiana University Press · Bloomington & Indianapolis

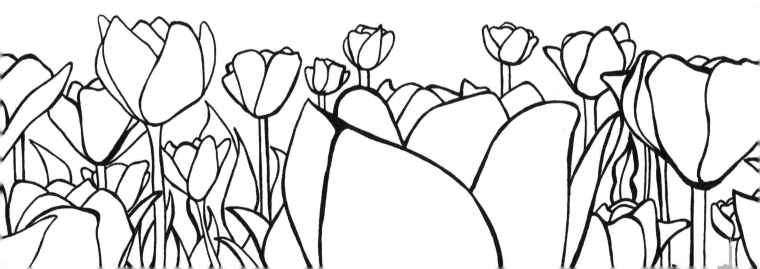

*For my mom and dad, who've been with me through every
sketch, charcoal drawing, painting, ink drawing, and art project.
Thank you for encouraging and funding me every step of the way.*

—Melissa Mueller

Quarry Books
an imprint of

Indiana University Press
Office of Scholarly Publishing
Herman B Wells Library 350
1320 East 10th Street
Bloomington, Indiana 47405 USA

iupress.indiana.edu

The paper used in this publication meets the minimum requirements
of the American National Standard for Information Sciences—
Permanence of Paper for Printed Library Materials, ANSI Z39.48-1992.

Manufactured in the United States of America

ISBN 978-0-253-02412-1 (pbk.)

1 2 3 4 5 20 19 18 17 16

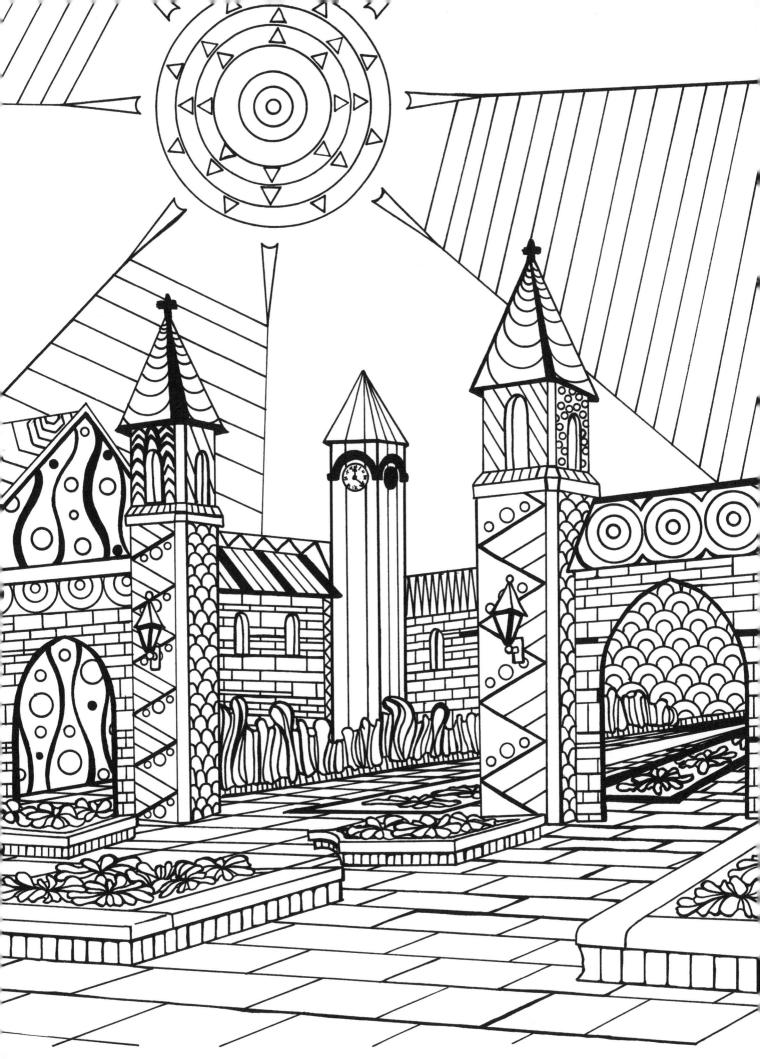

PRESS

Sample Gates

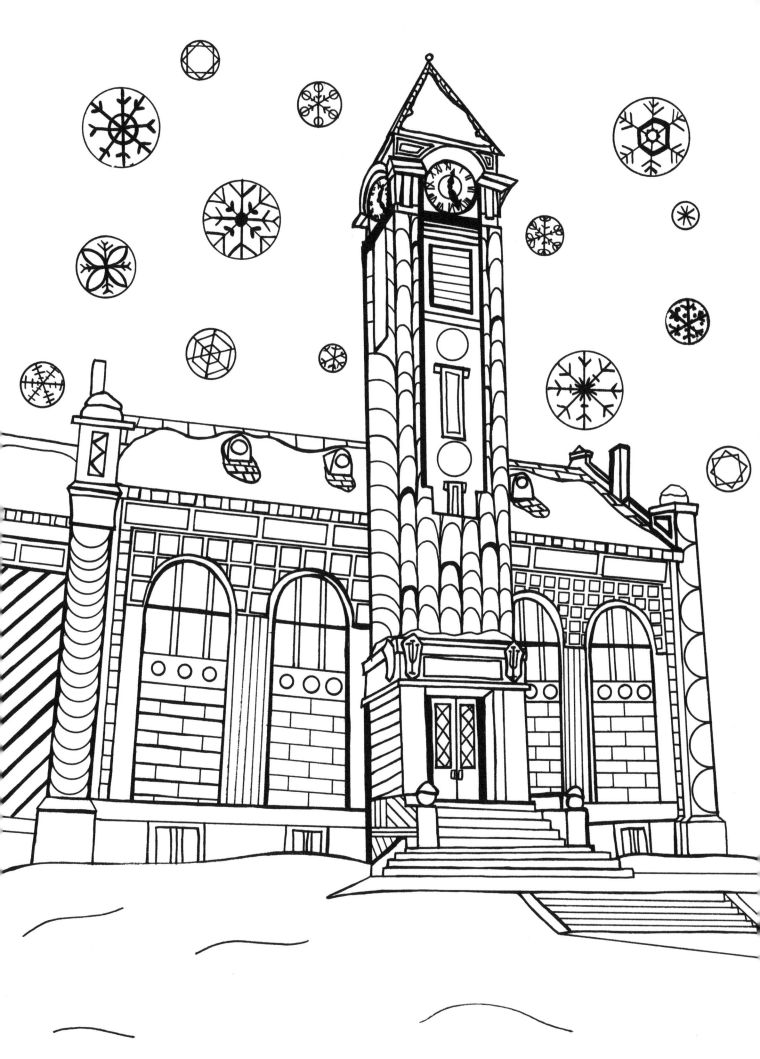

Student Building

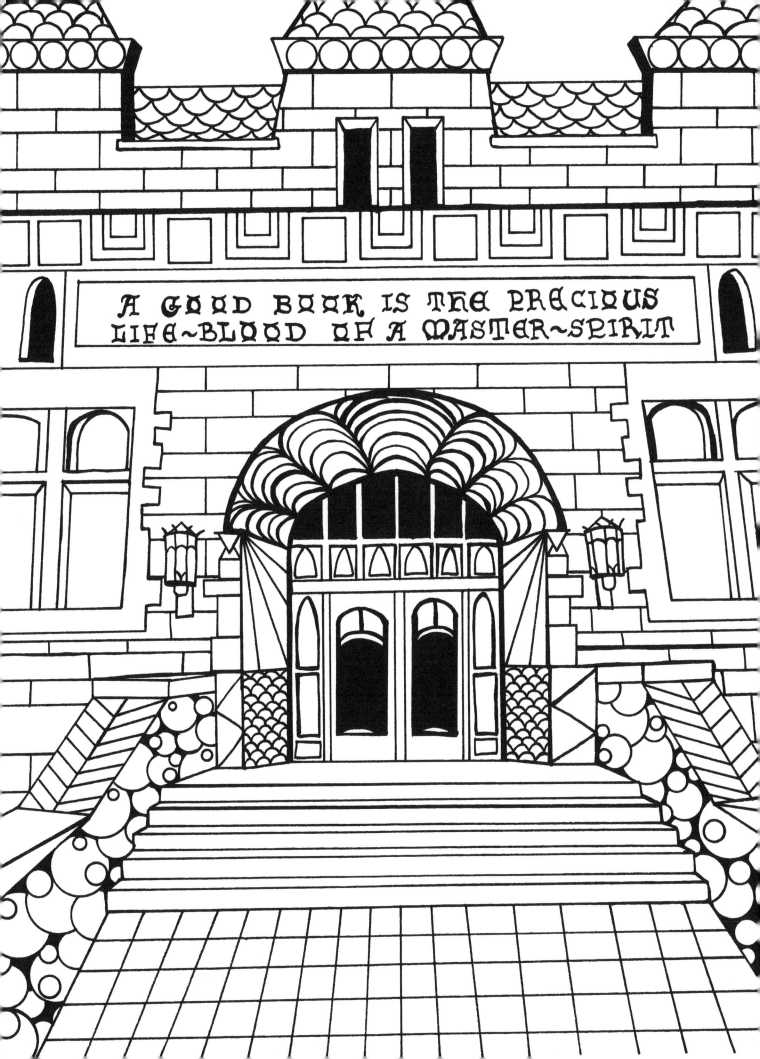

Franklin Hall

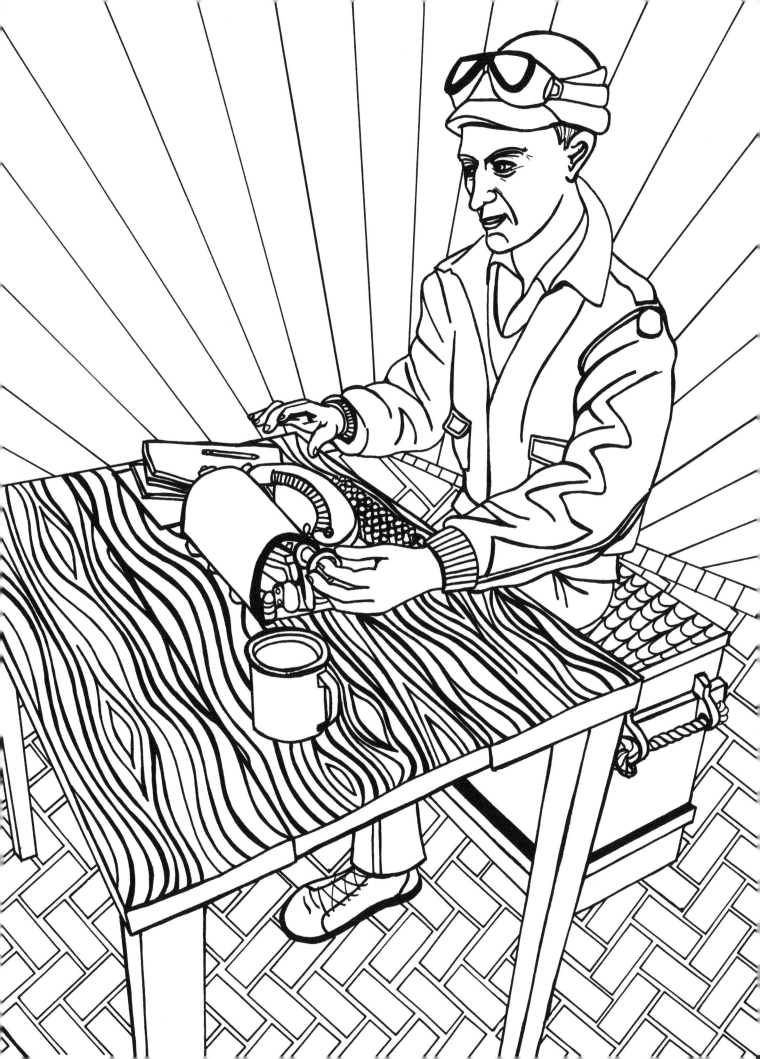

Ernie Pyle statue

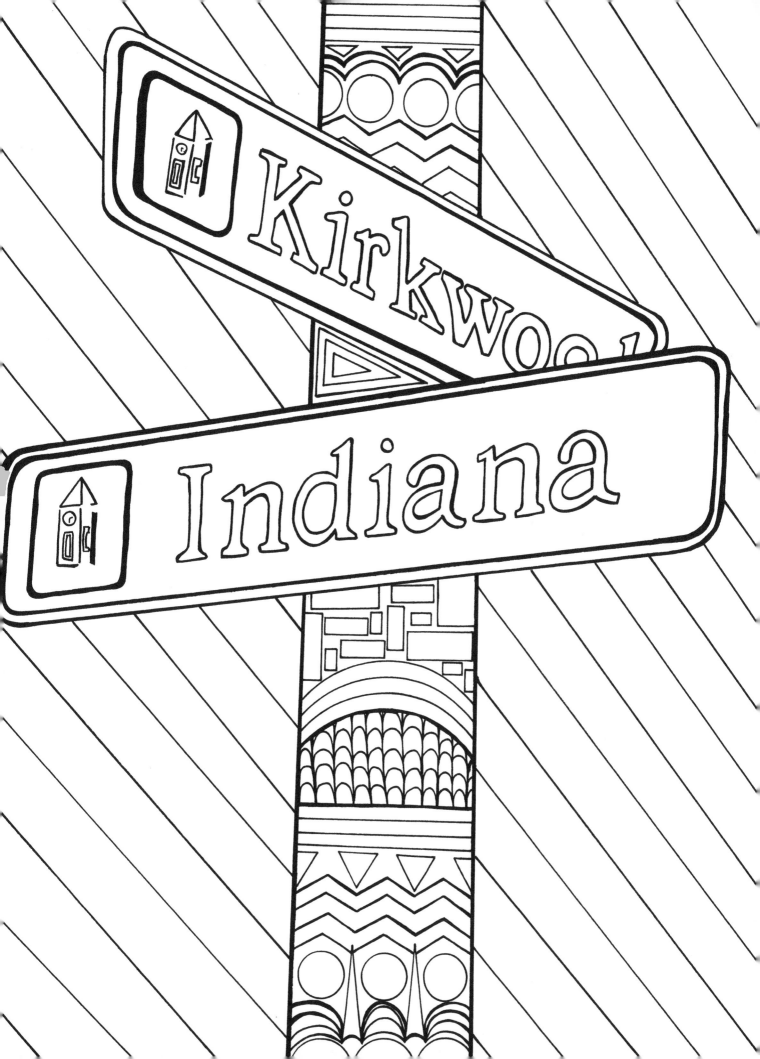

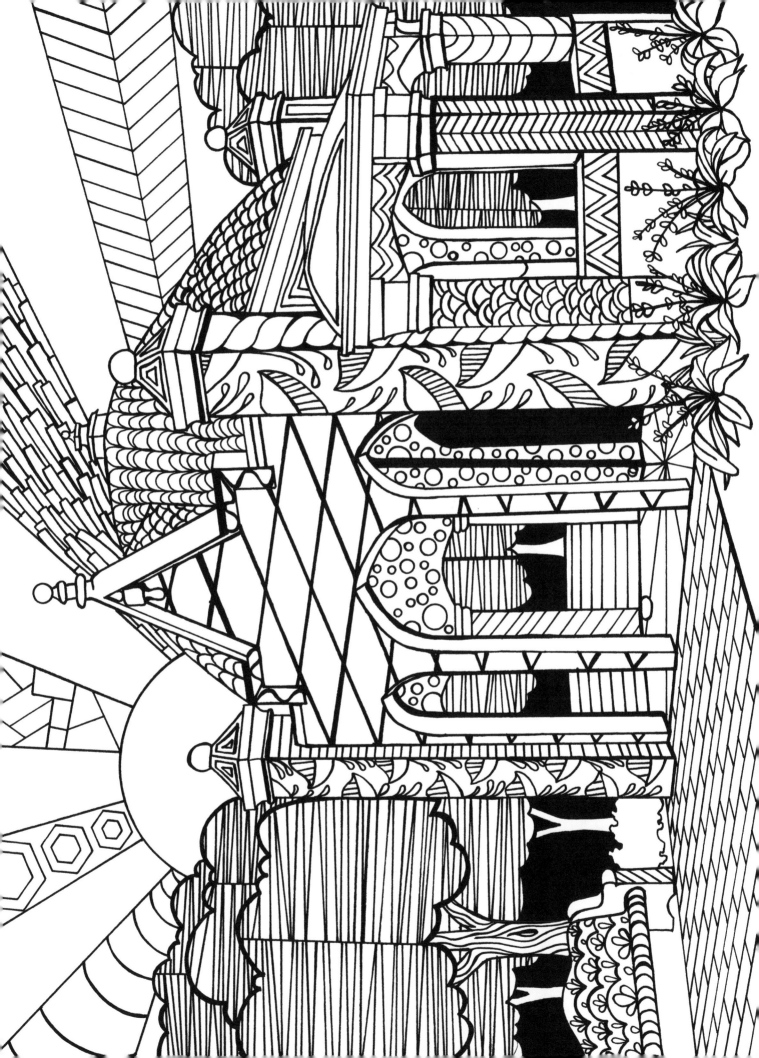

Rose Well House

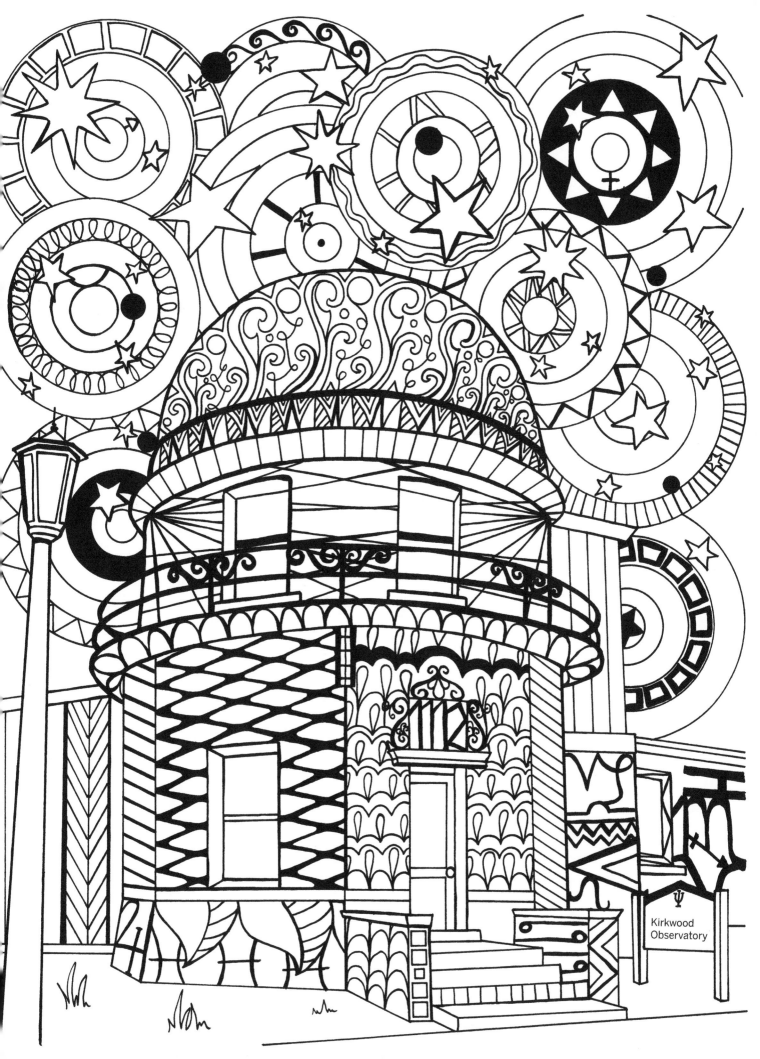

Kirkwood
Observatory

Kirkwood Observatory

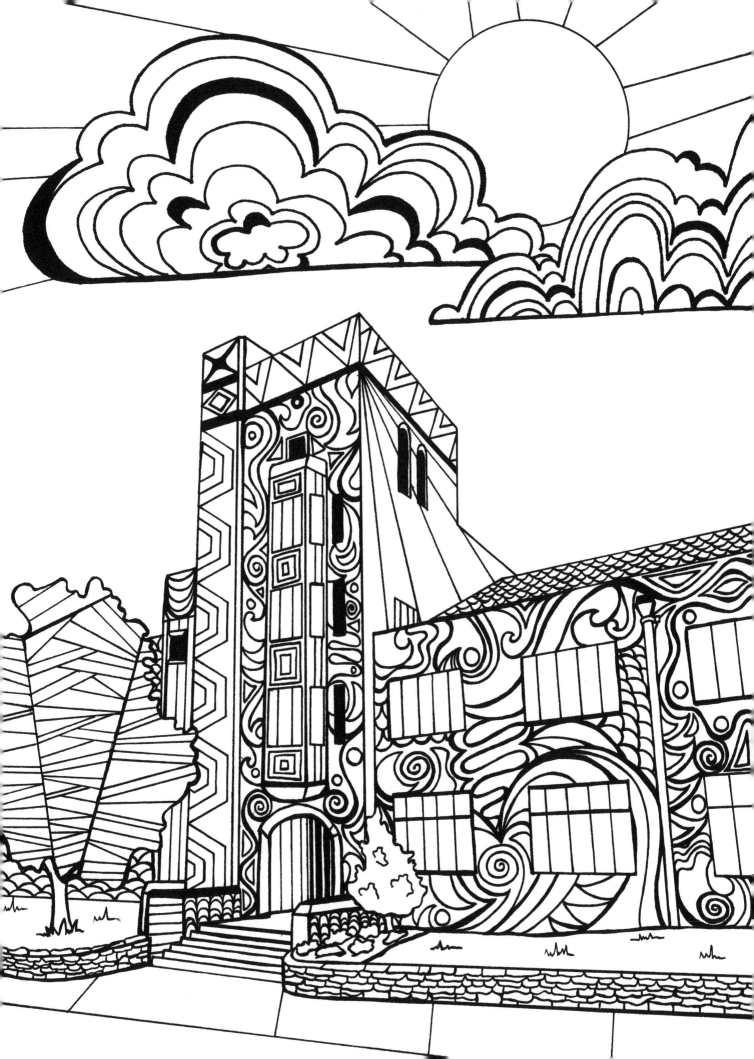

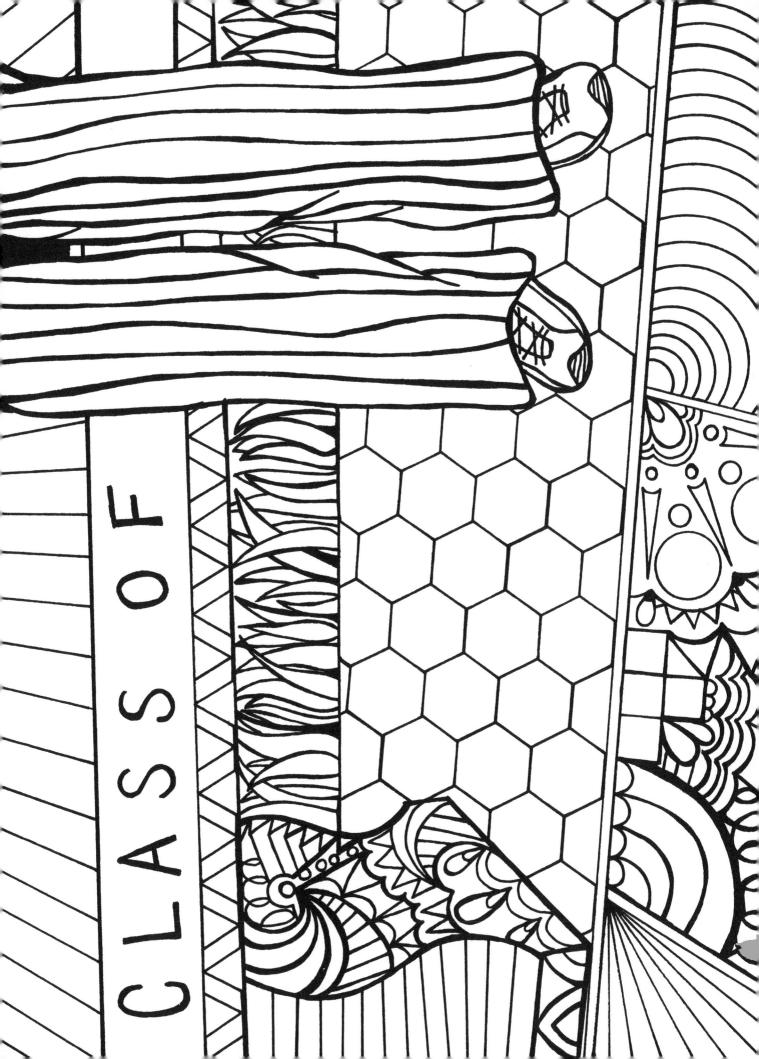

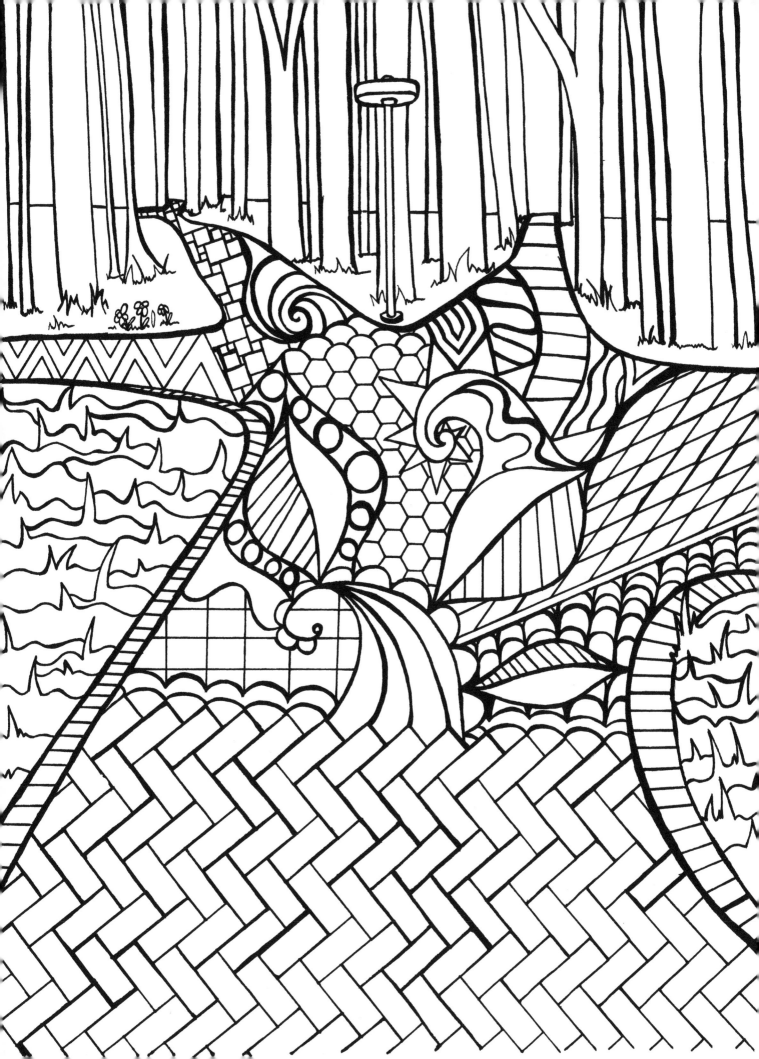

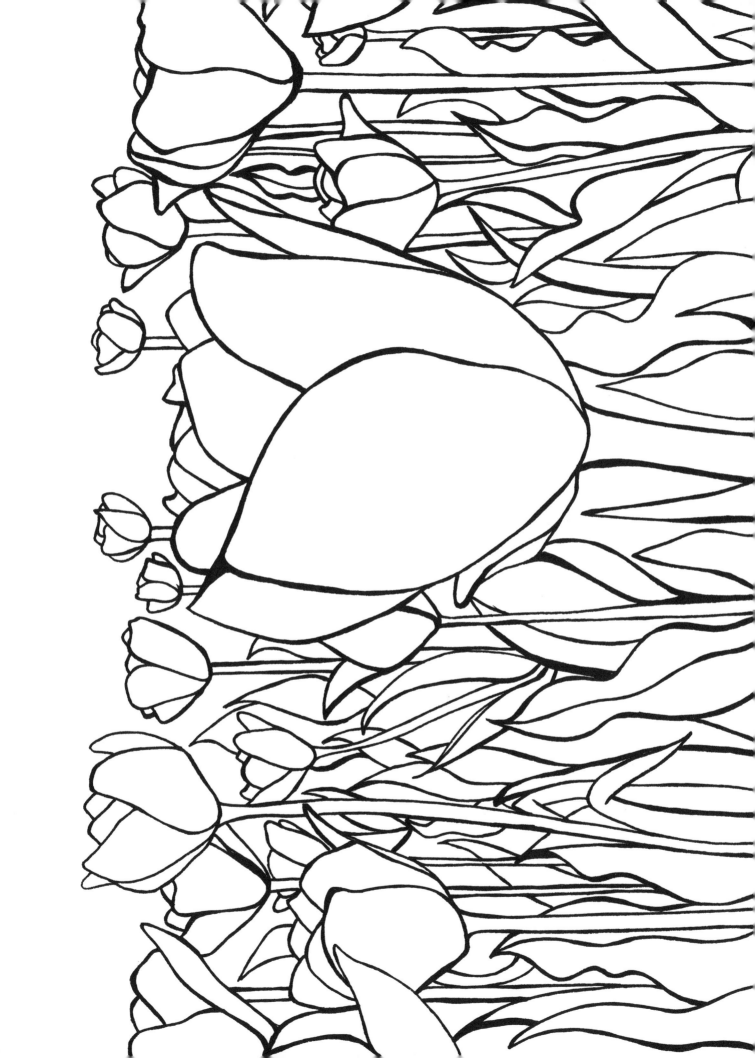

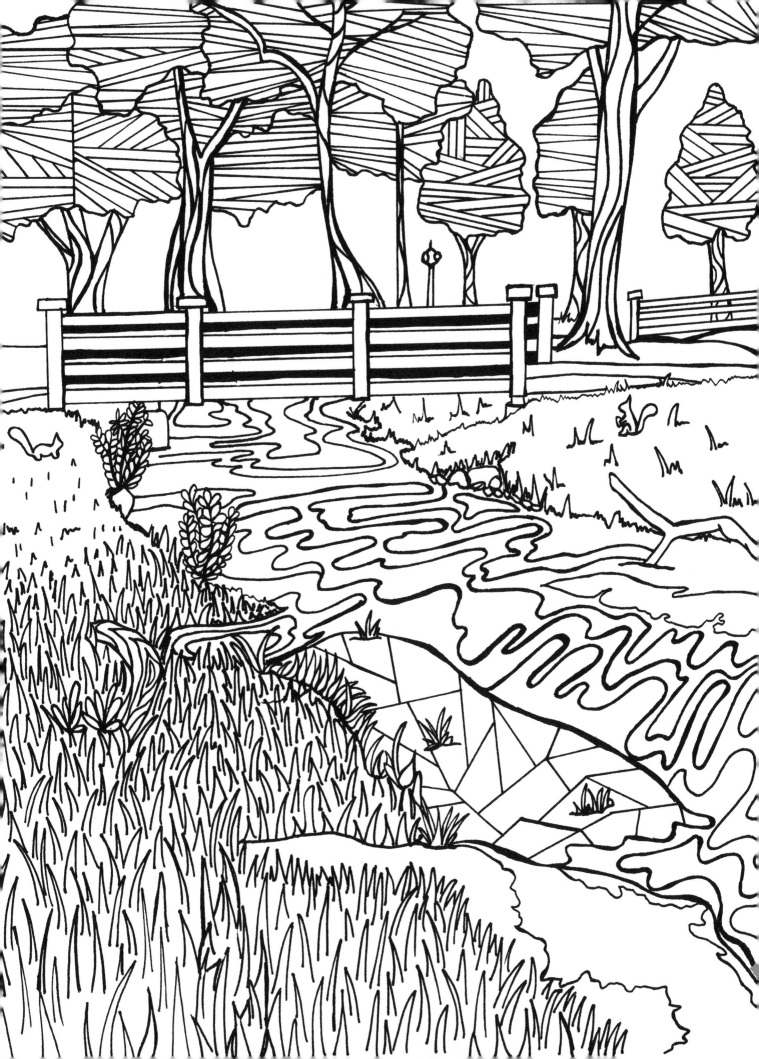

Jordan River

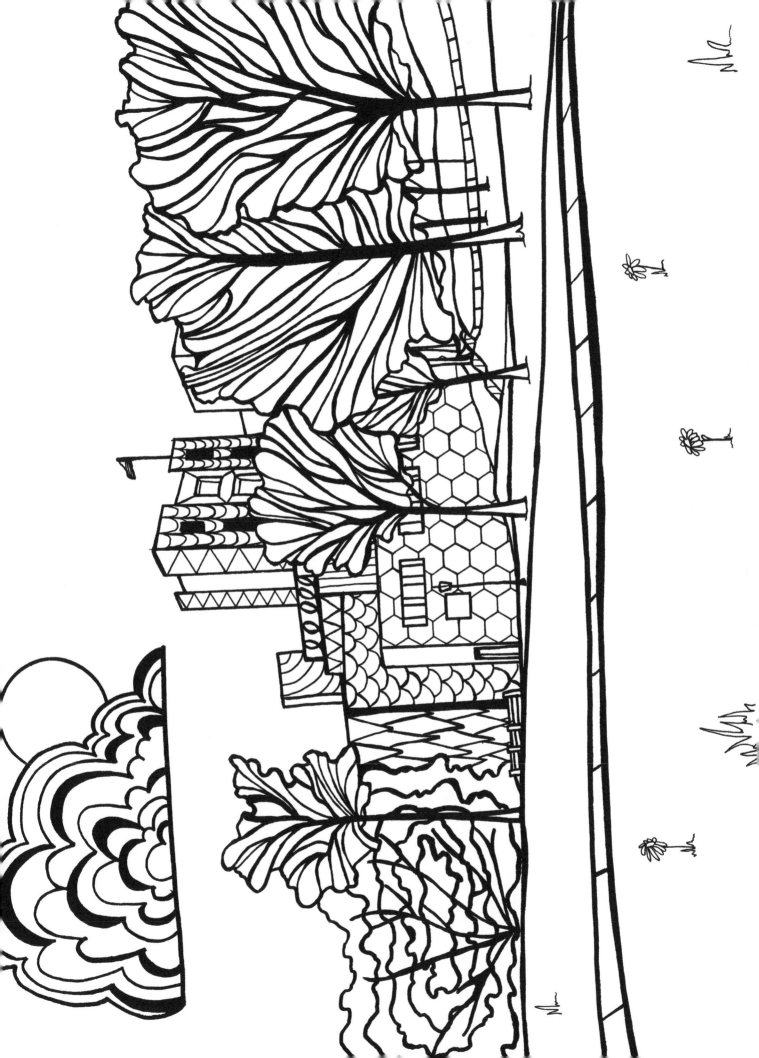

PRESS

Dunn Meadow

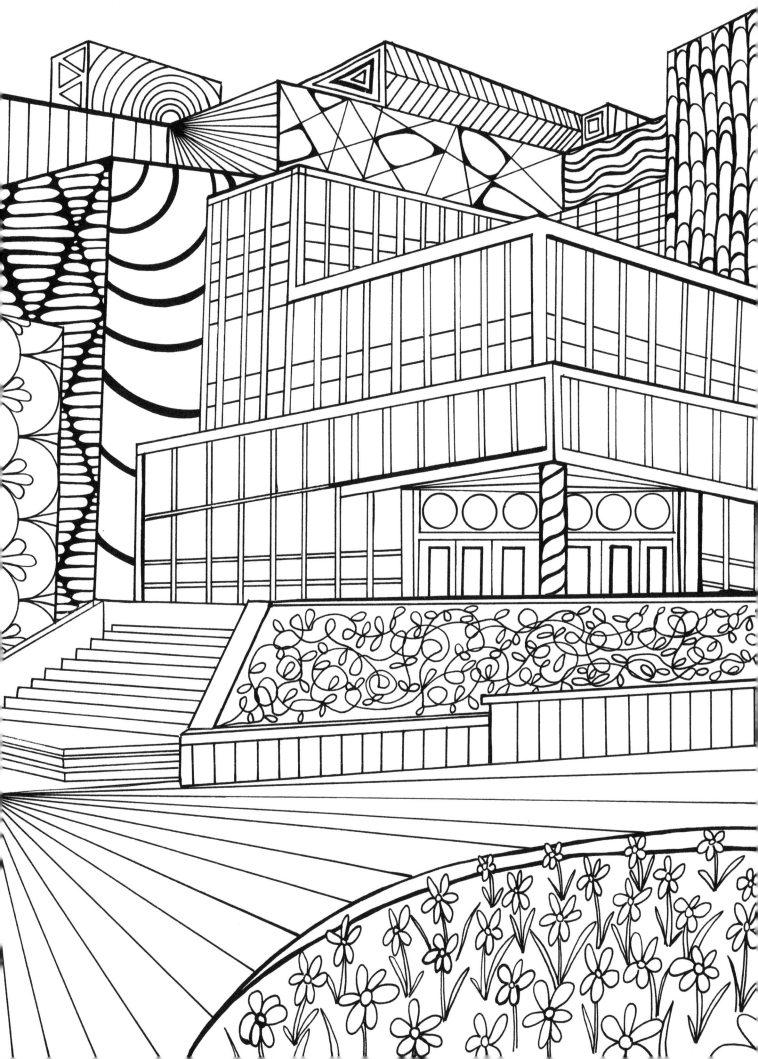

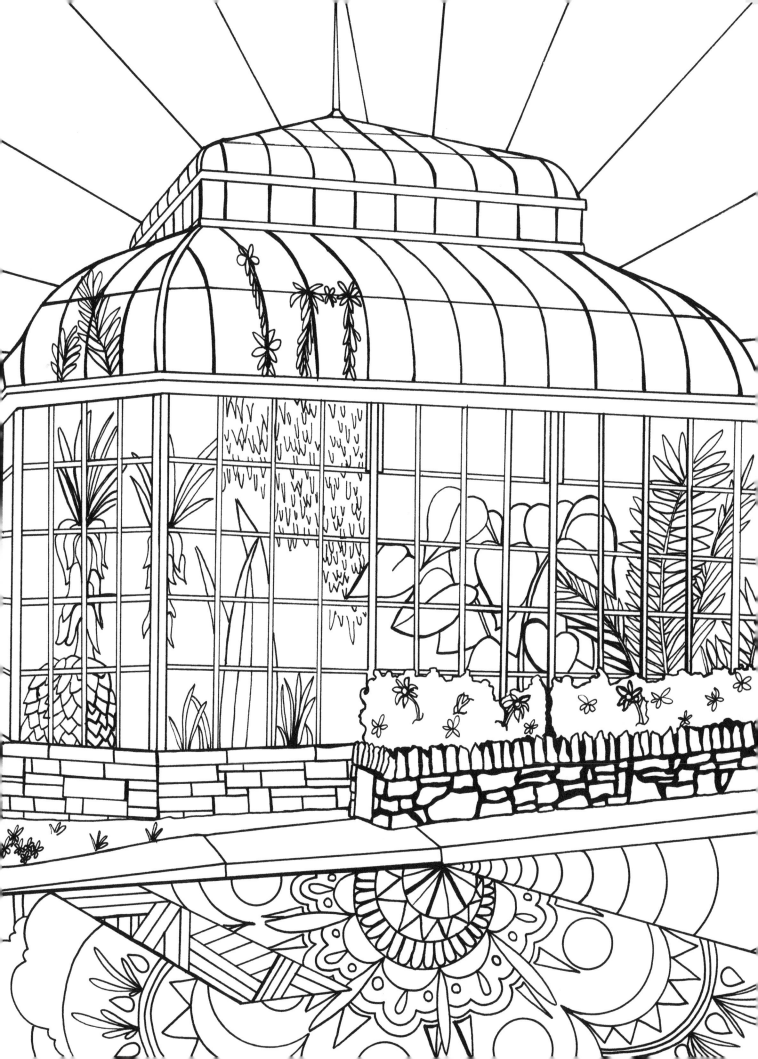

Jordan Hall Greenhouse

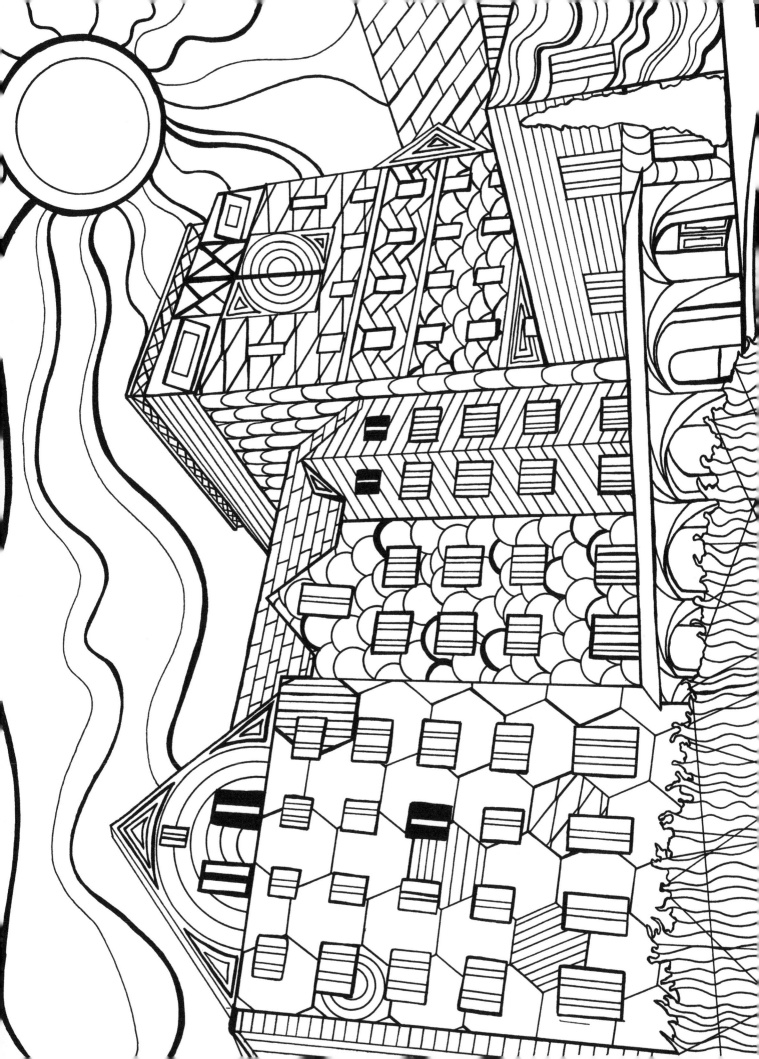

Indiana Memorial Union

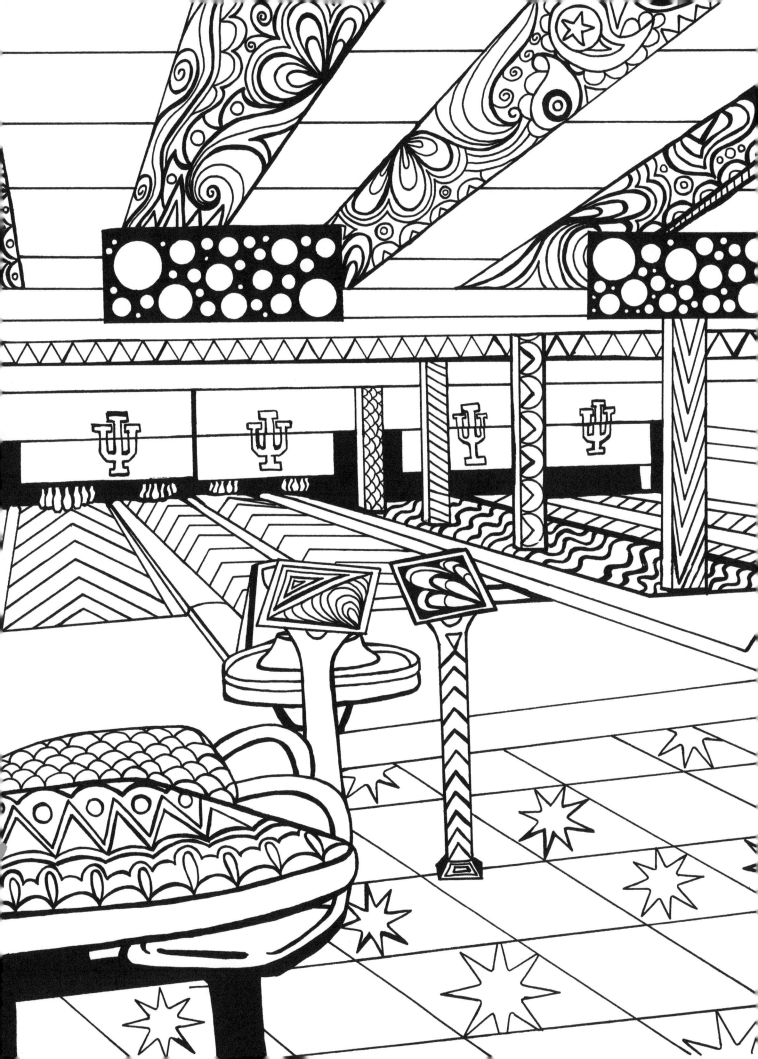

Indiana Memorial Union Bowling & Billiards

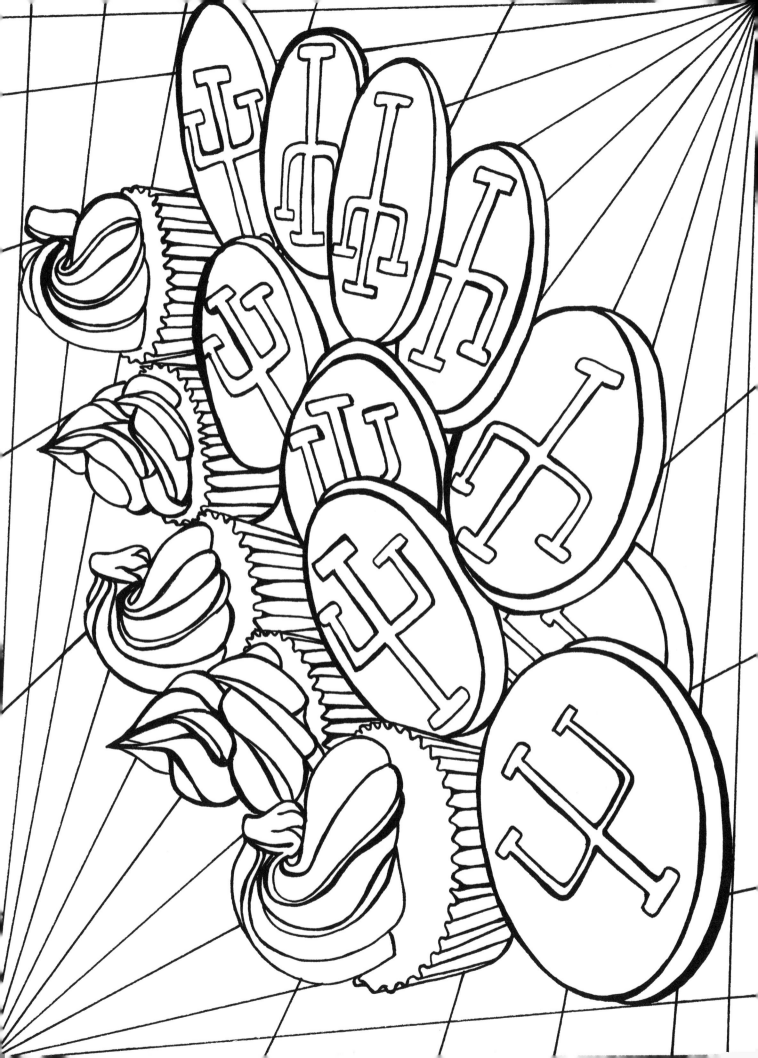

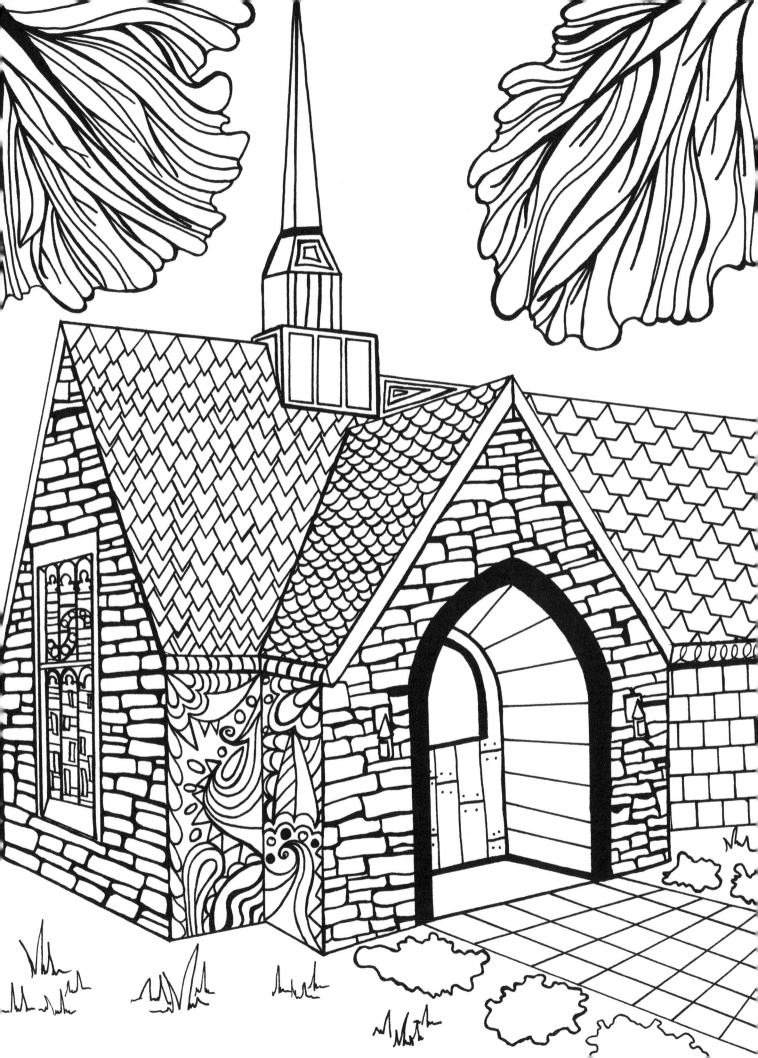

Beck Chapel

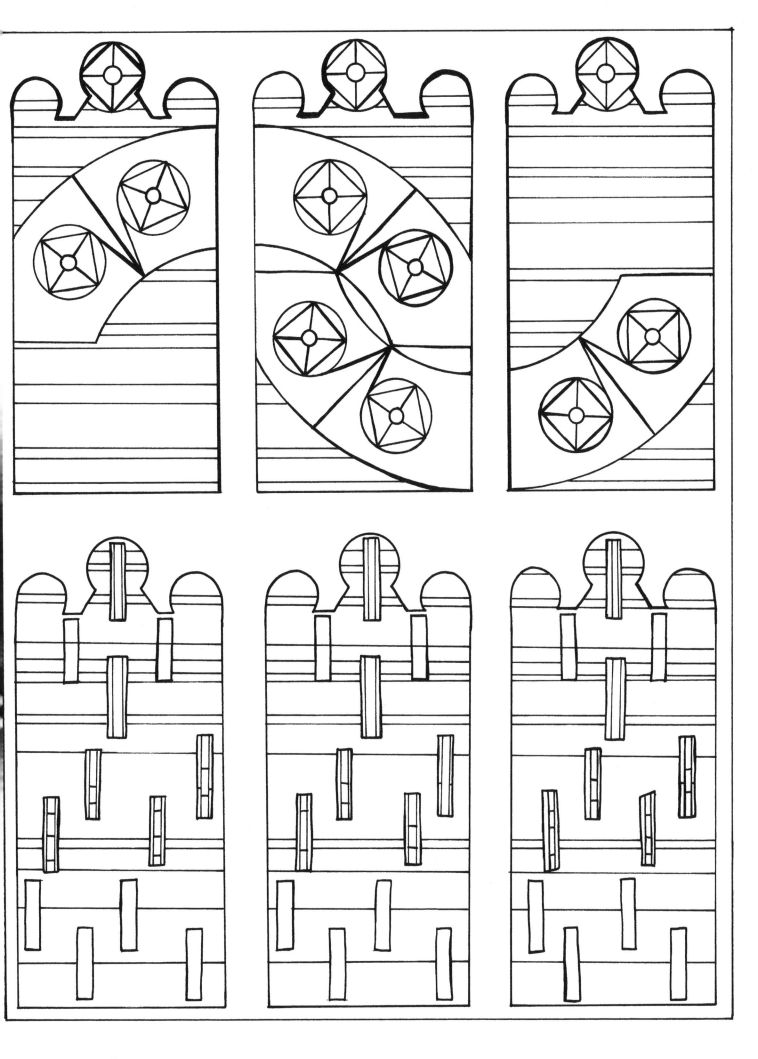

Beck Chapel's stained glass

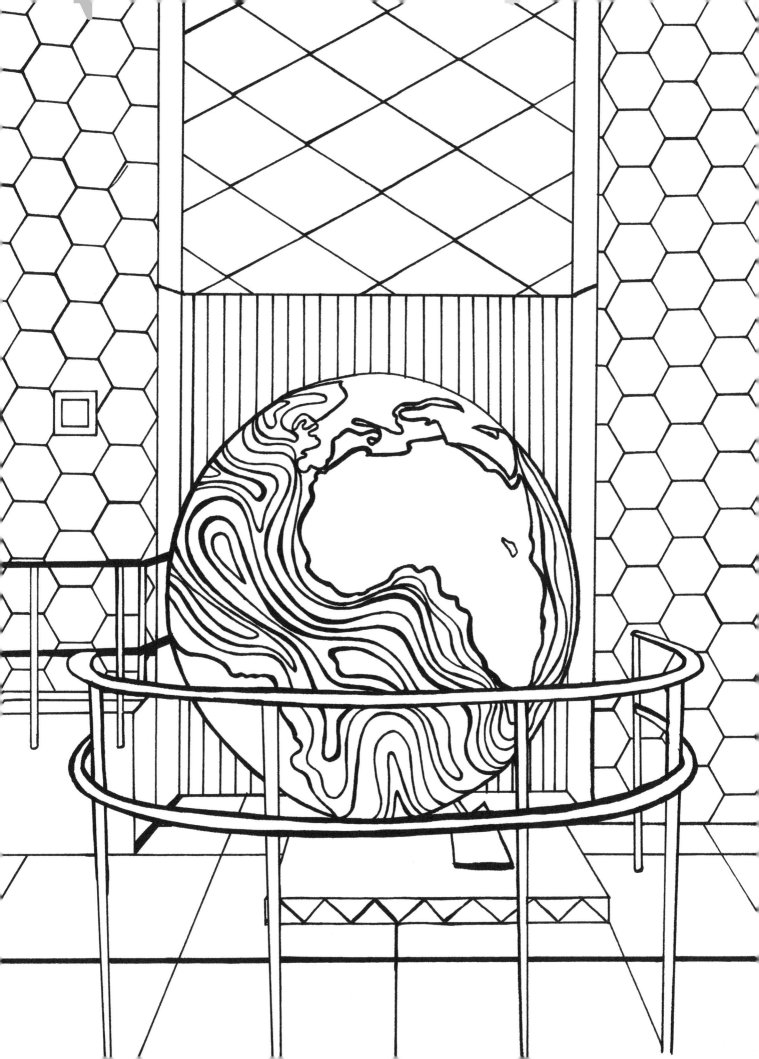

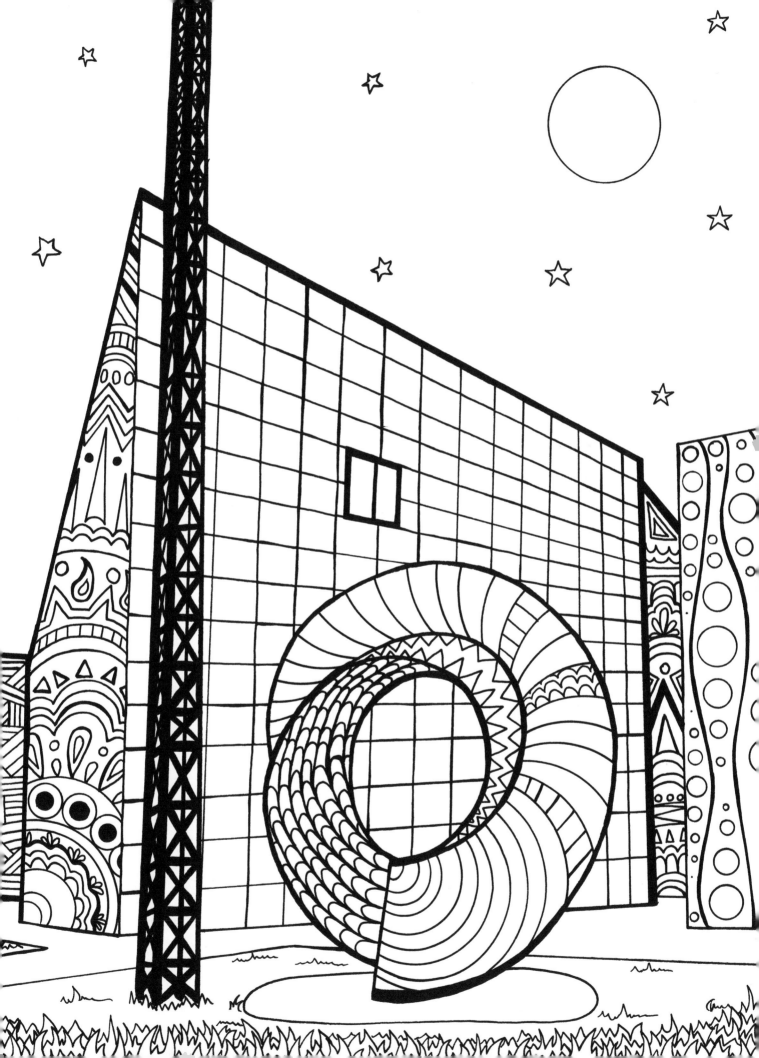

The Eskenazi Museum of Art exterior

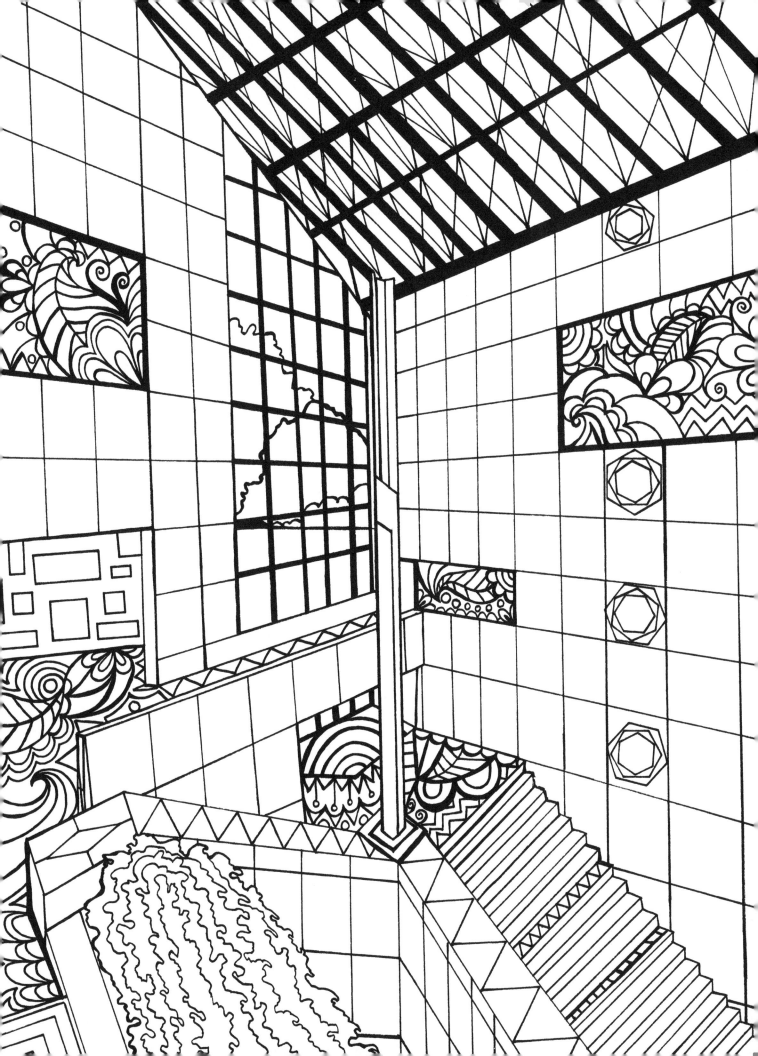

The Eskenazi Museum of Art interior

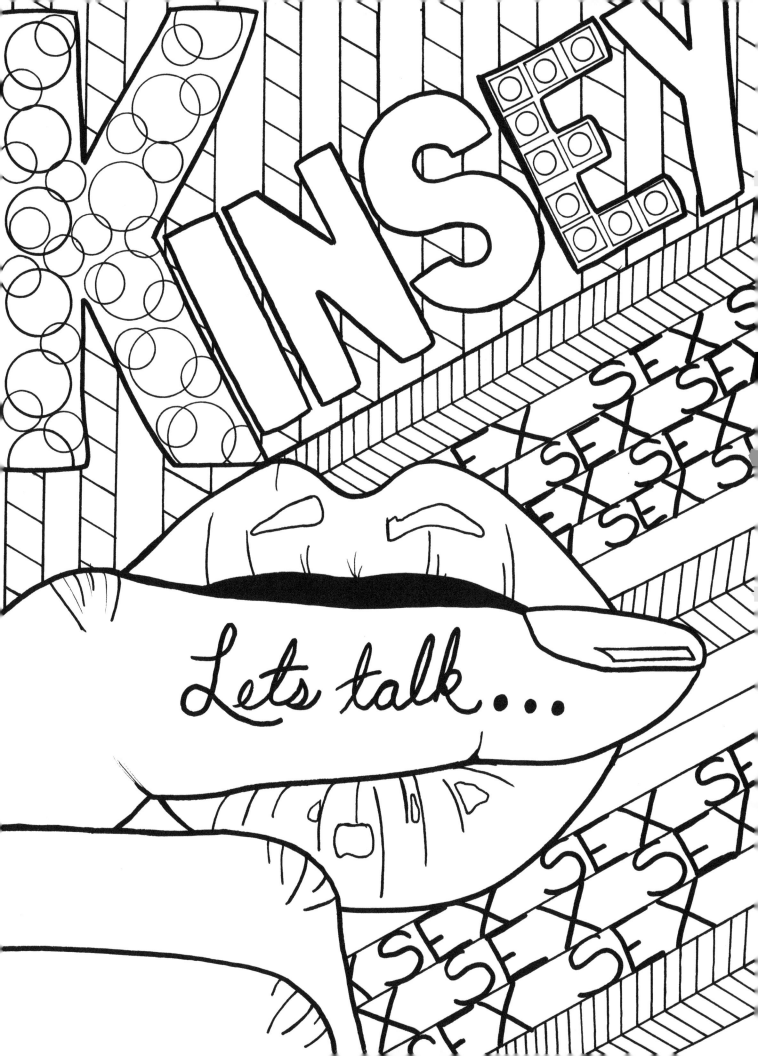

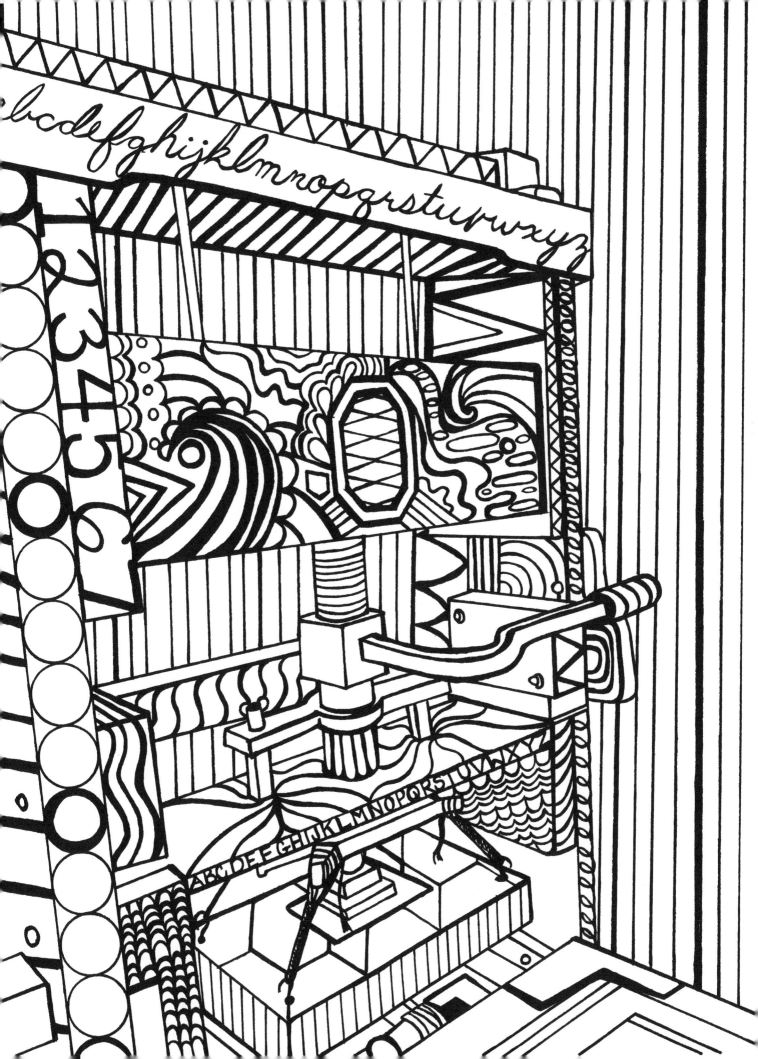

Lilly Library's printing press

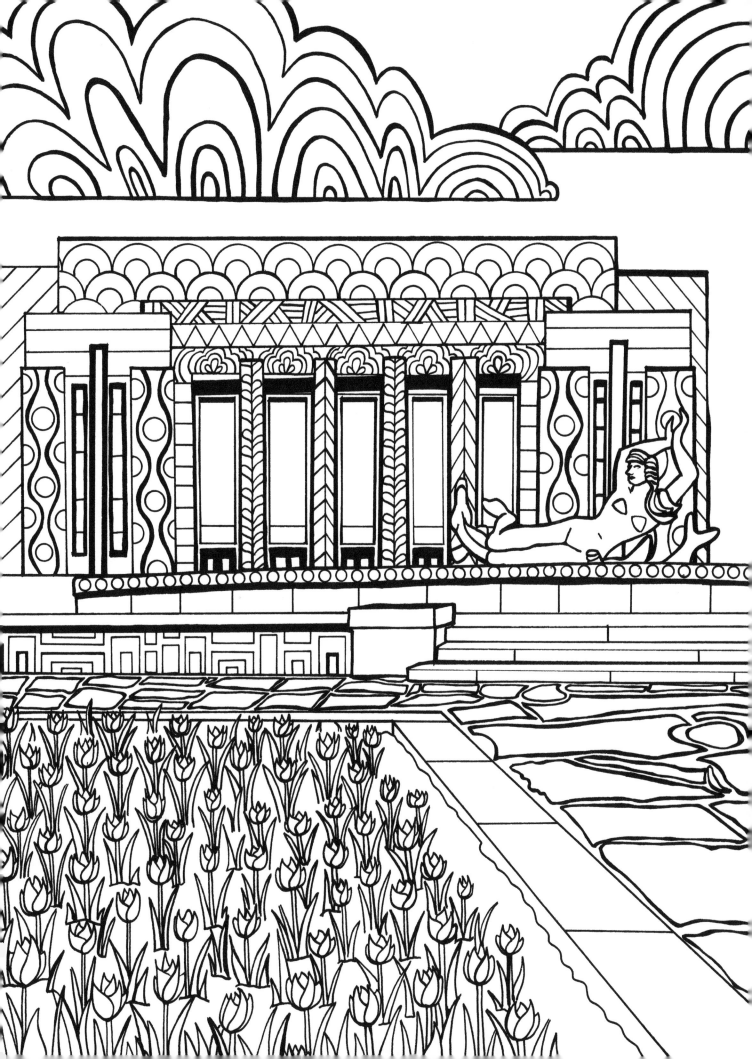

Indiana University Auditorium and Showalter Fountain

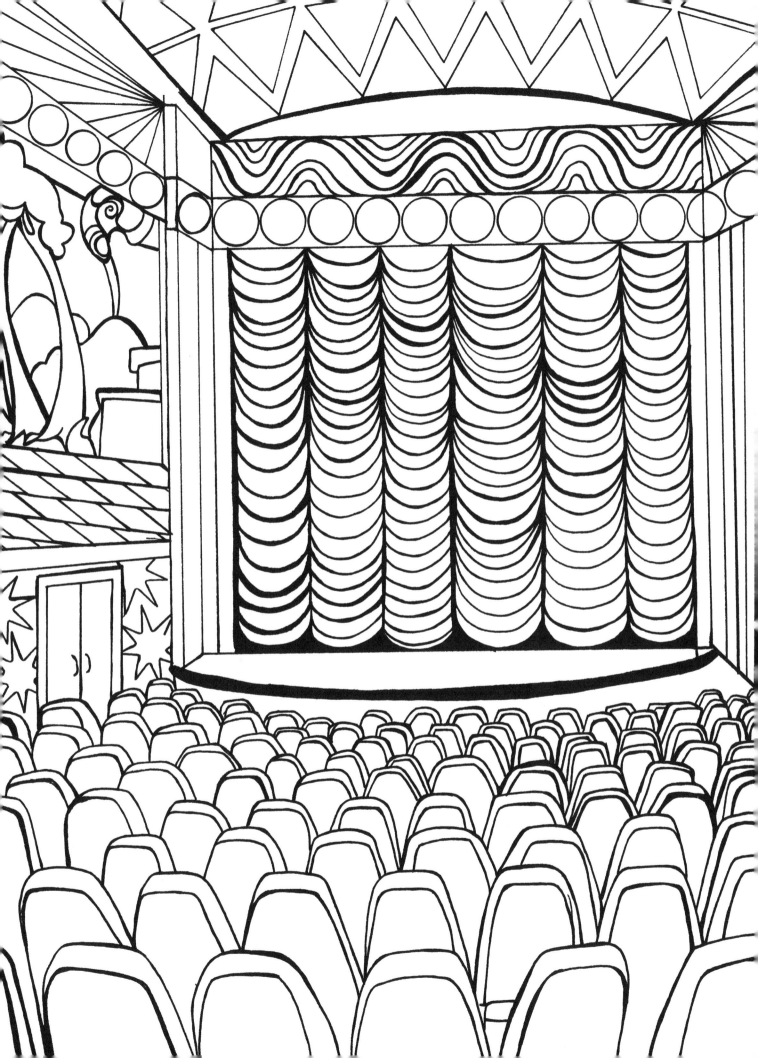

Indiana University Cinema

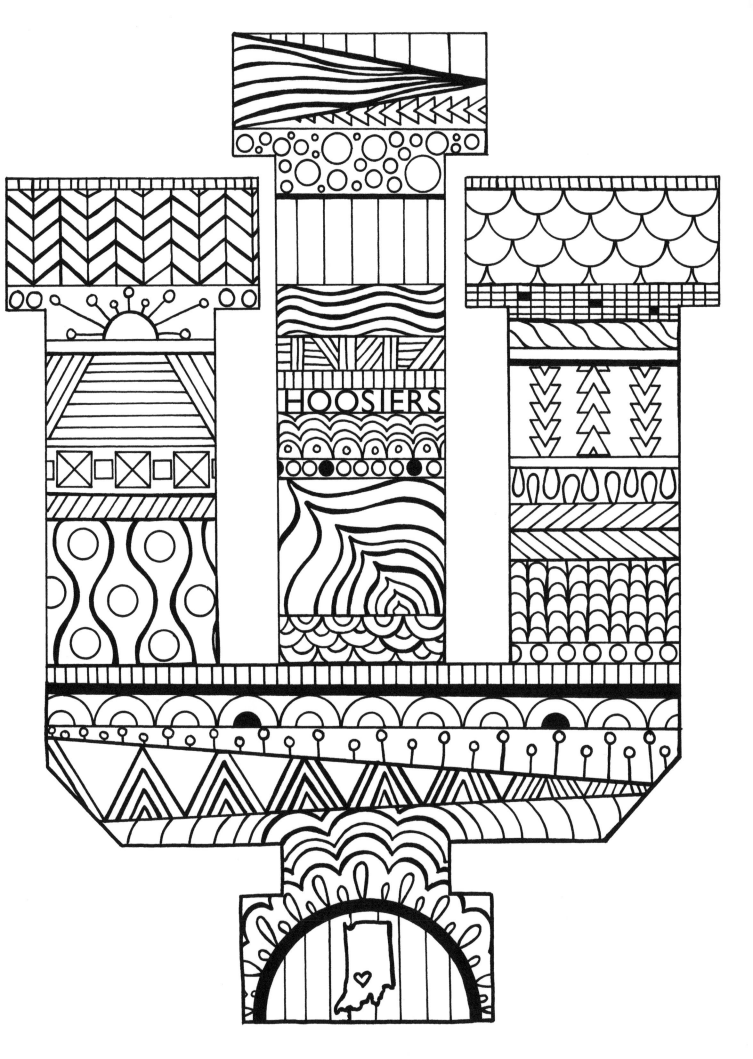

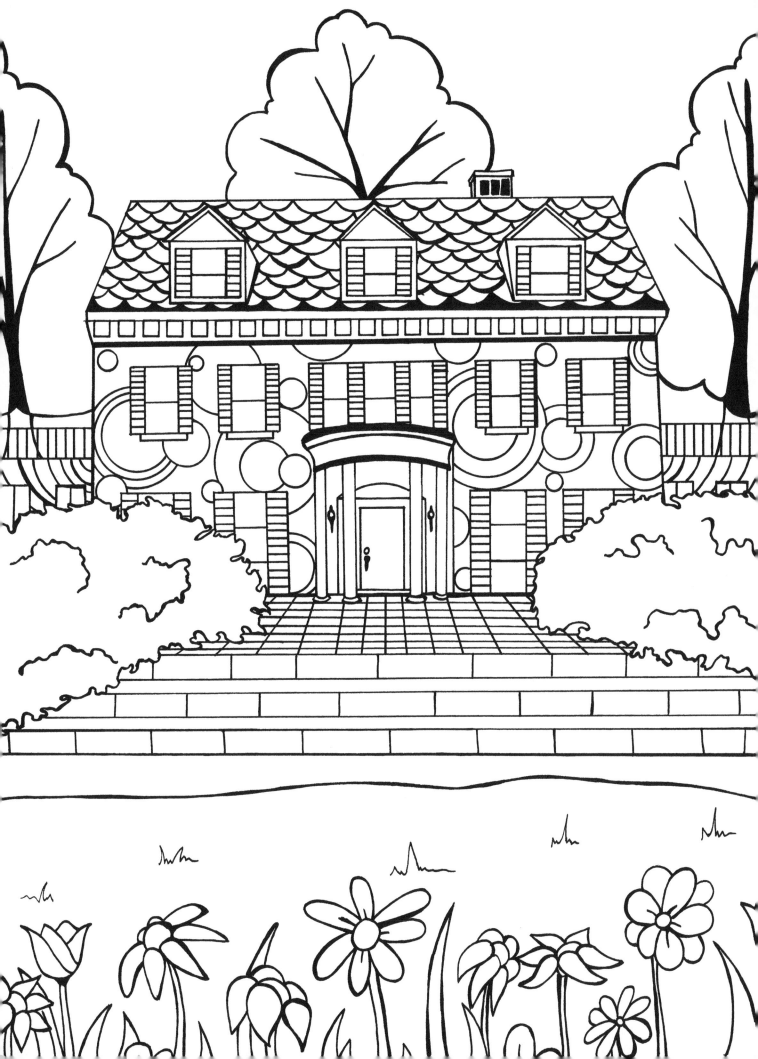

Bryan House

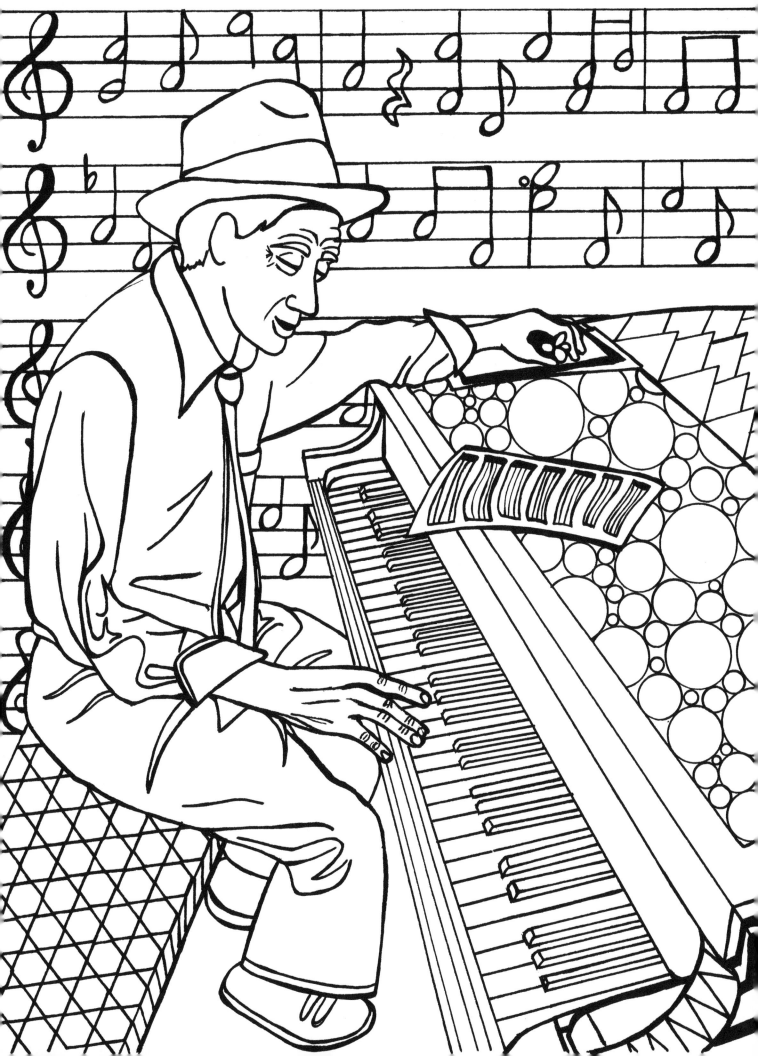

Hoagy Carmichael statue

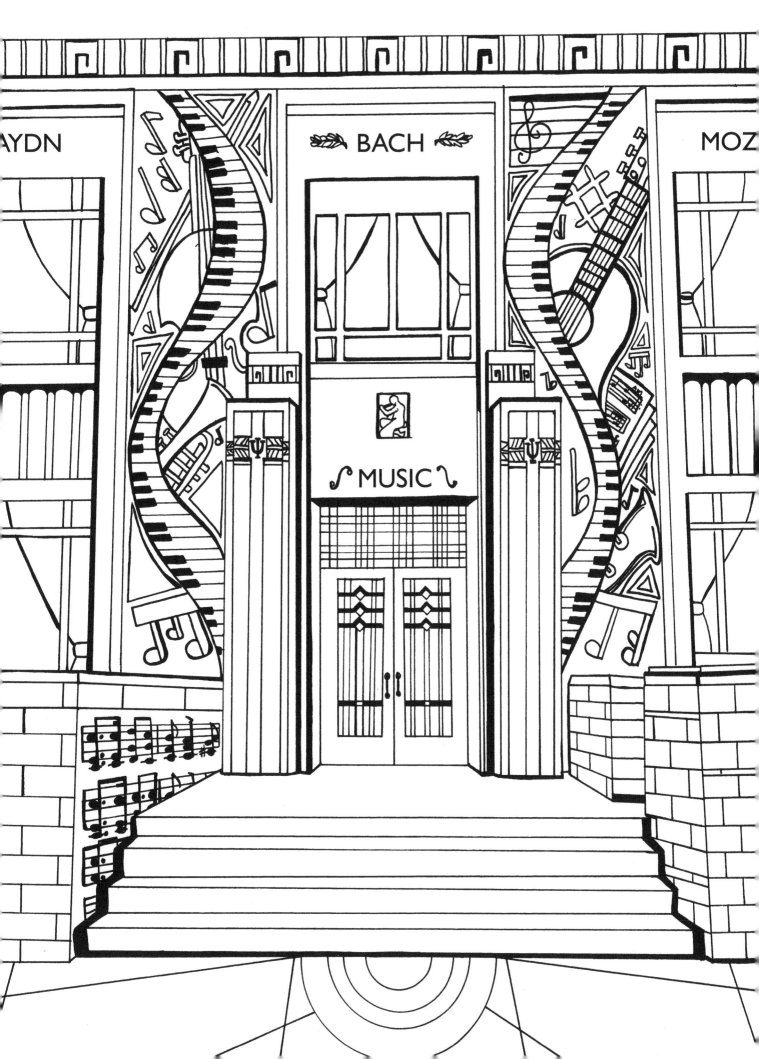

Jacobs School of Music Recital Hall

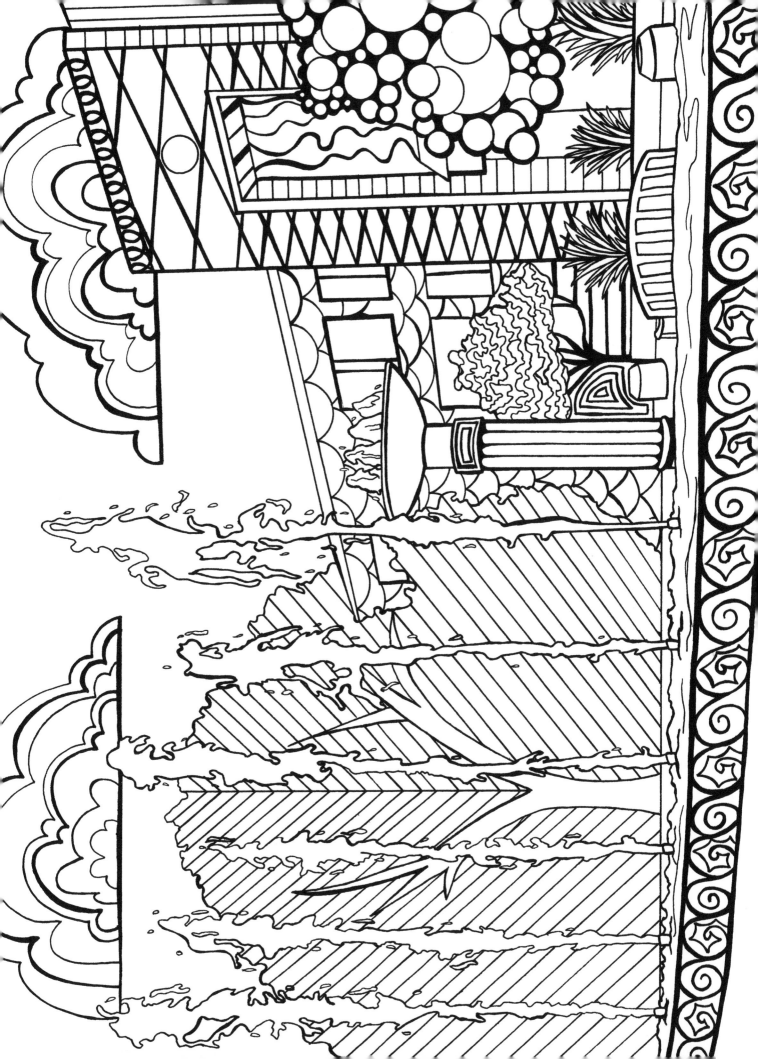

Jacobs School of Music Ford-Crawford Hall

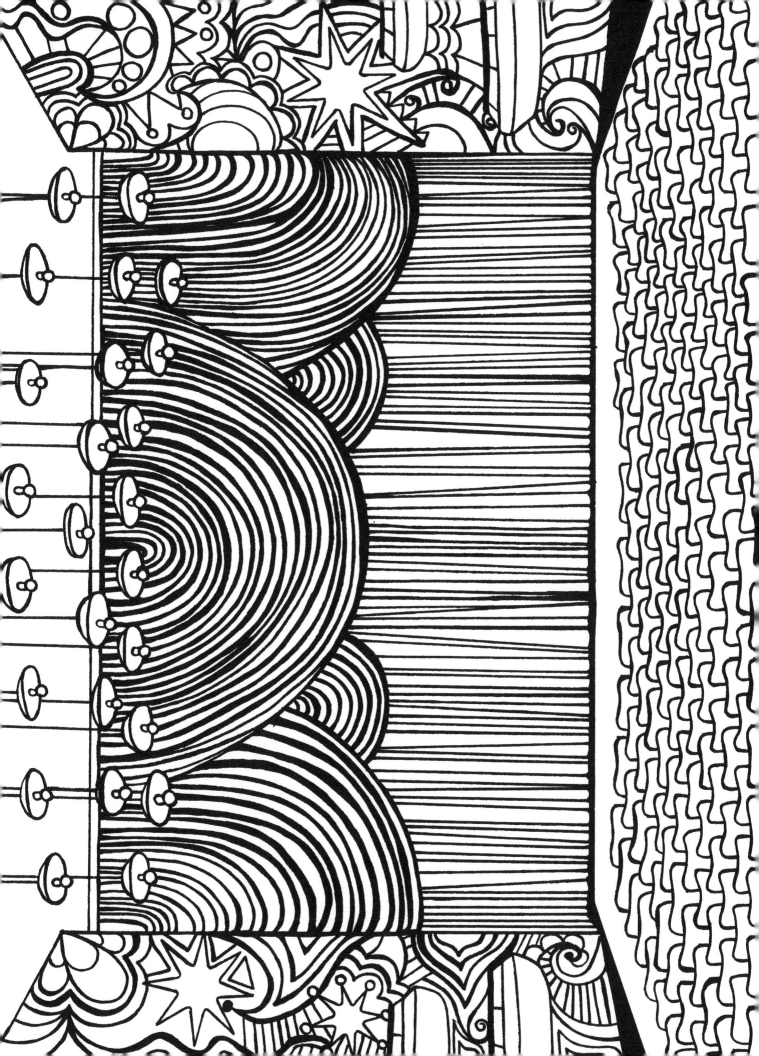

Musical Arts Center

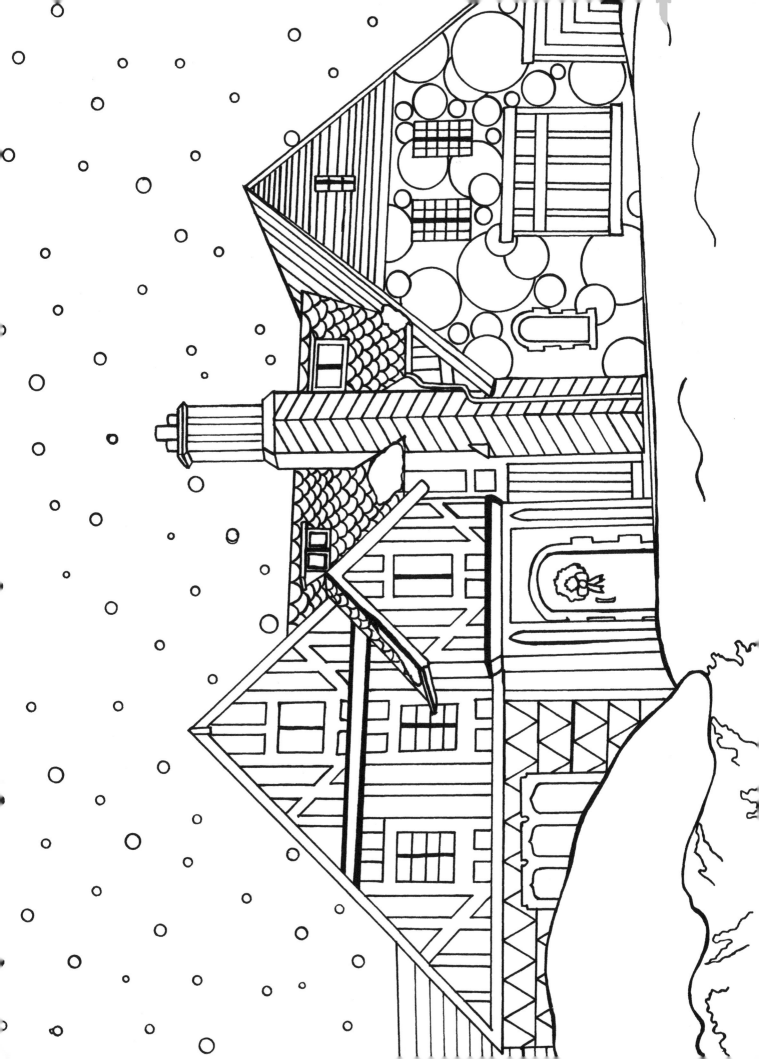

Leo R. Dowling International Center

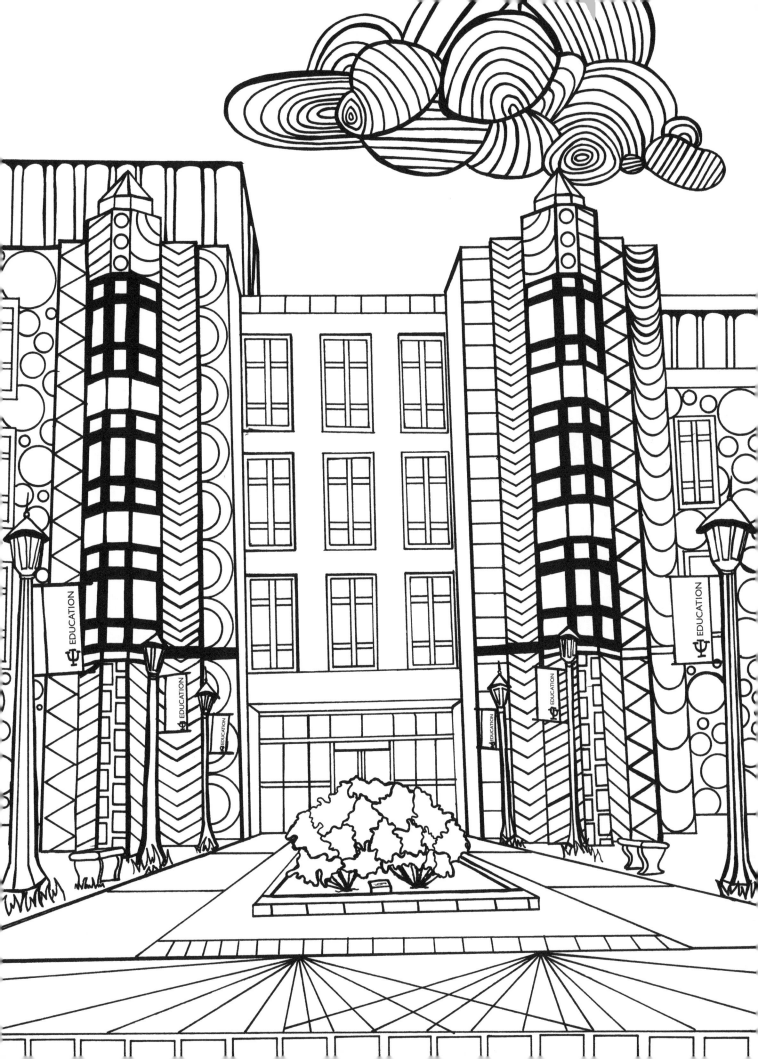

School of Education

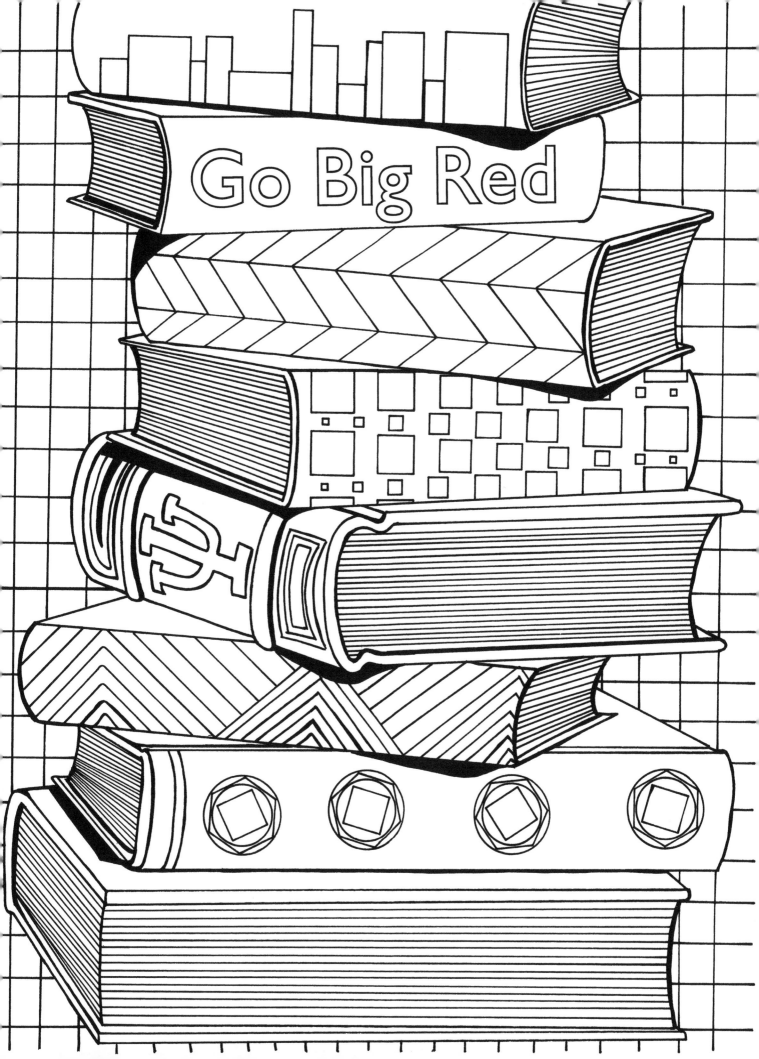

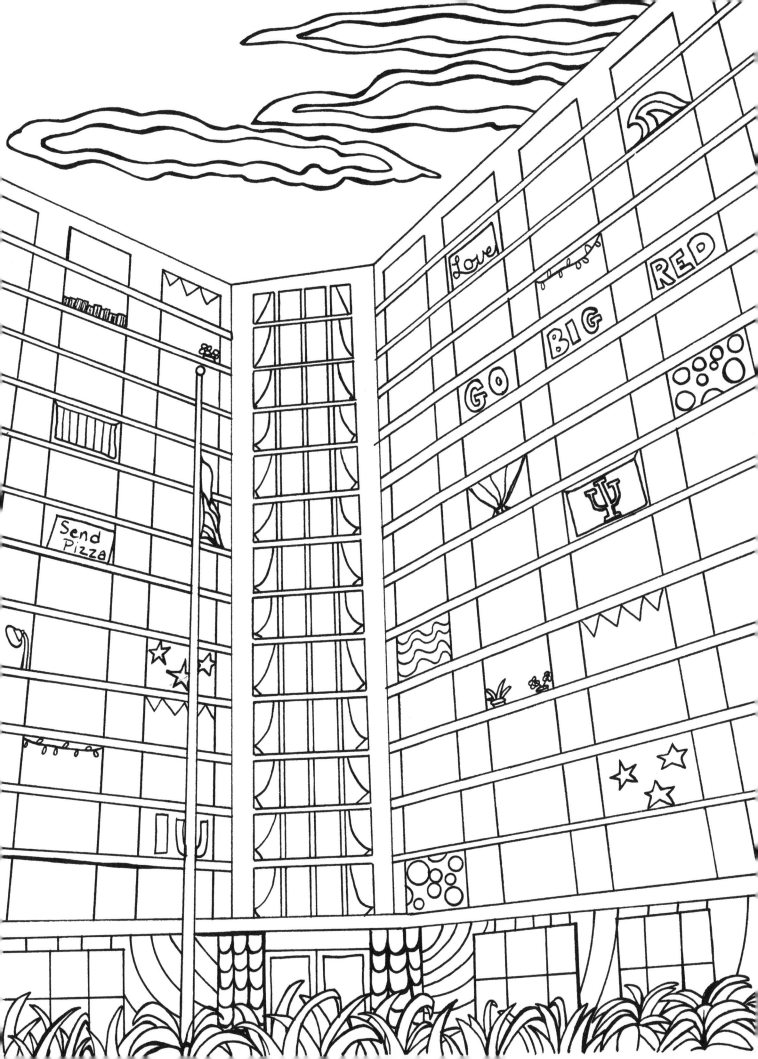

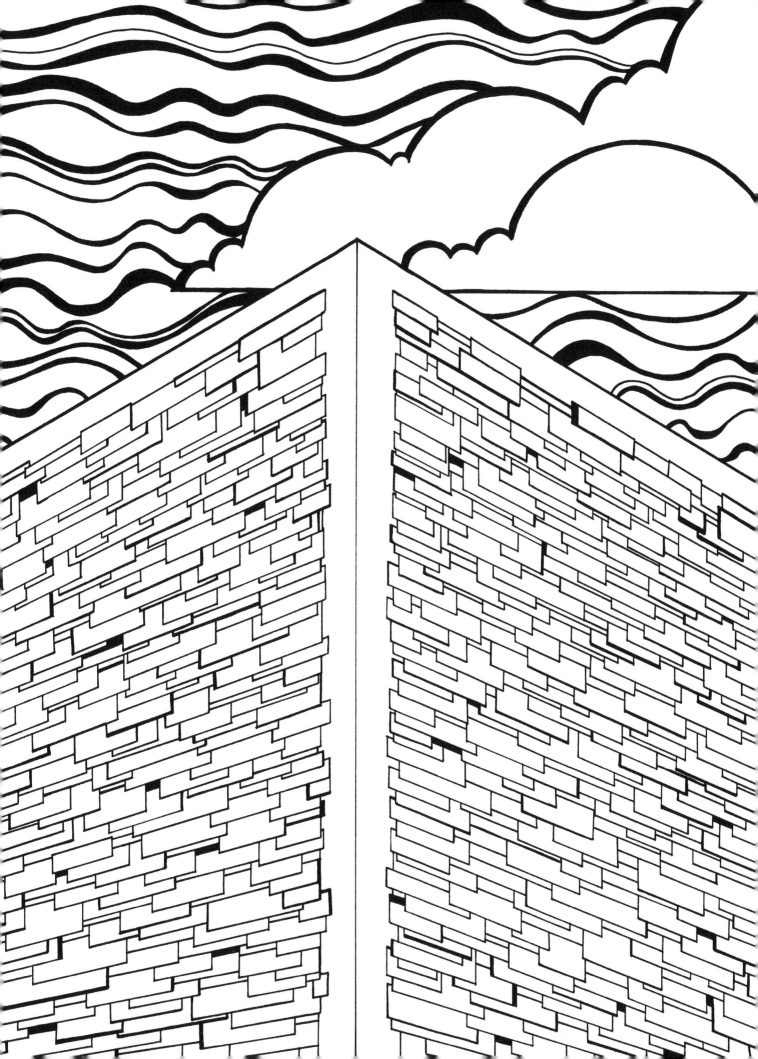

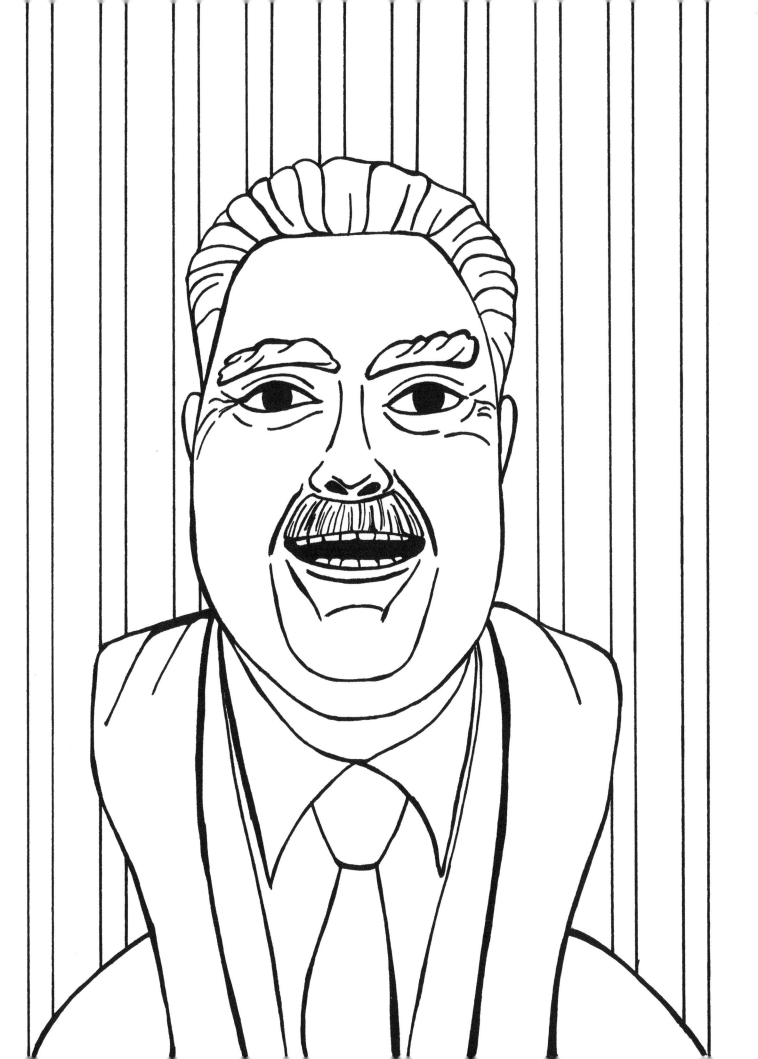

PRESS

Herman B Wells statue

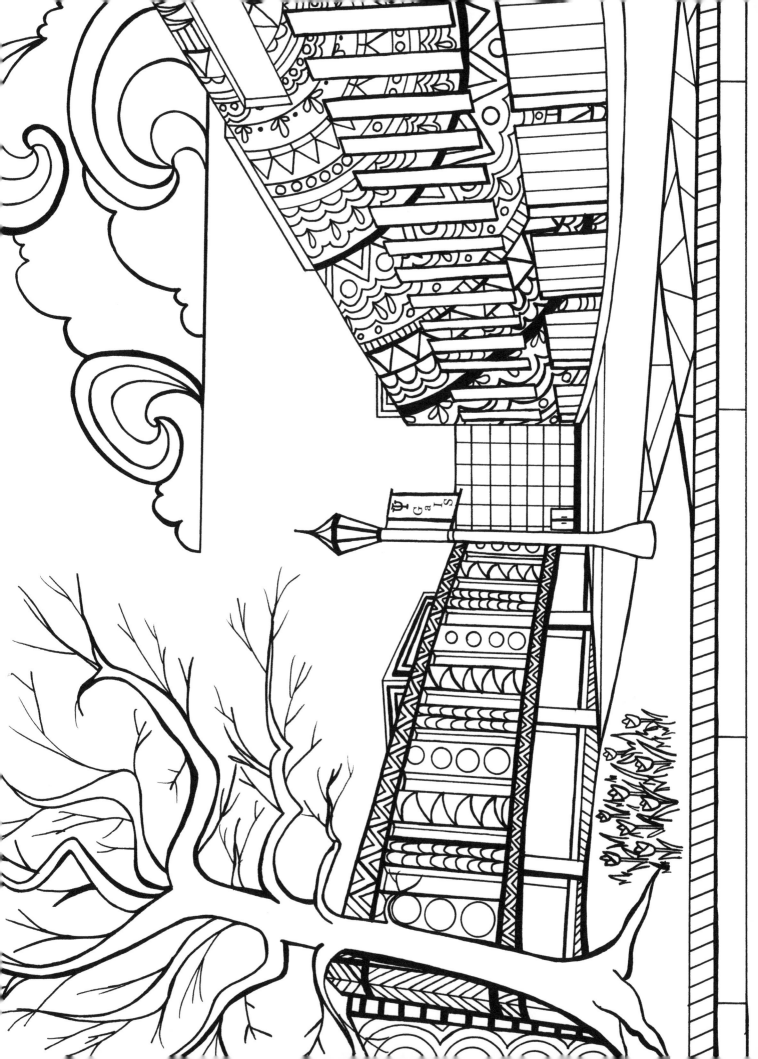

School of Global and International Studies

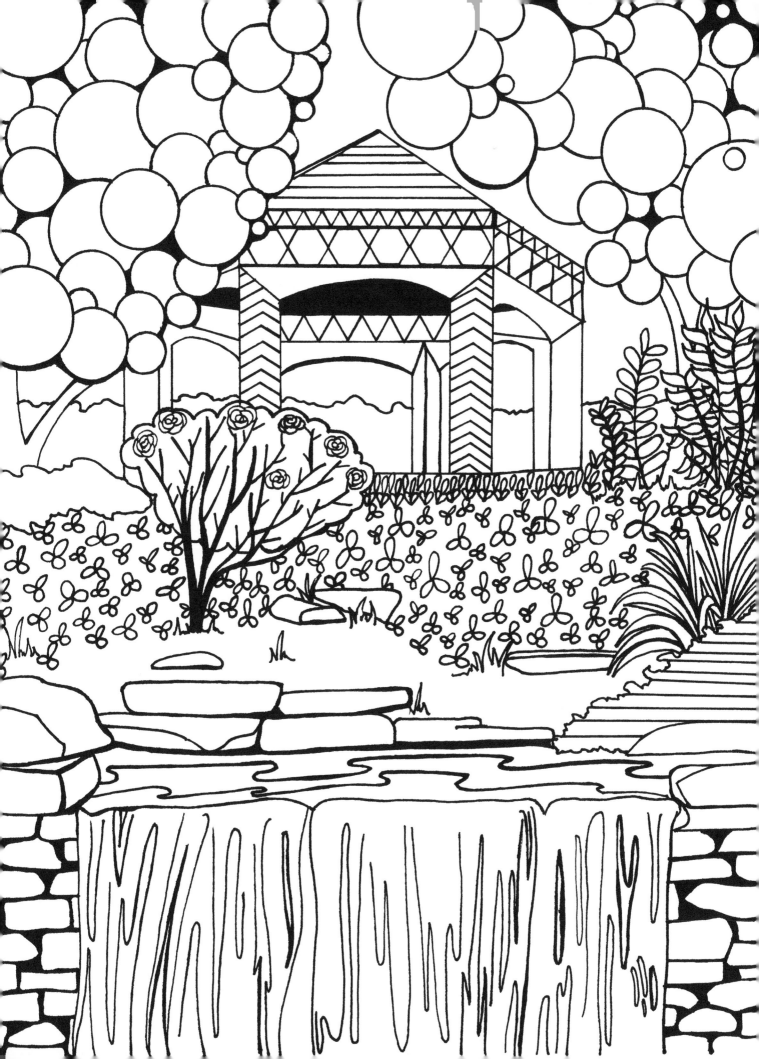

Arboretum Gazebo

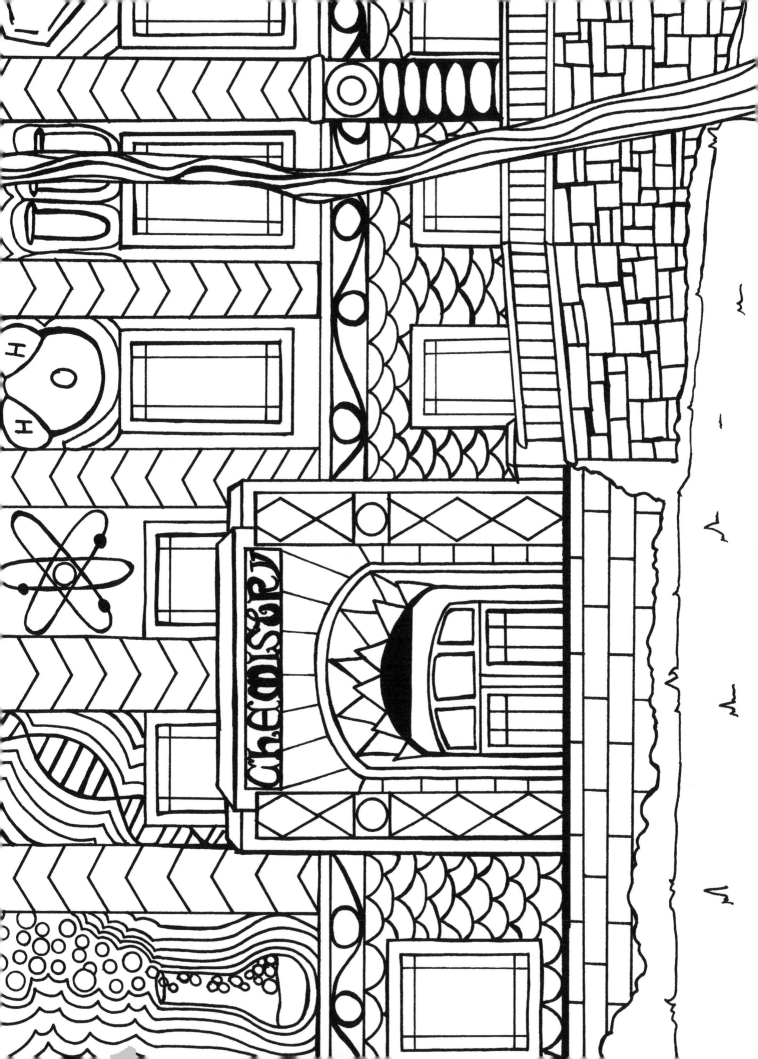

Chemistry Building

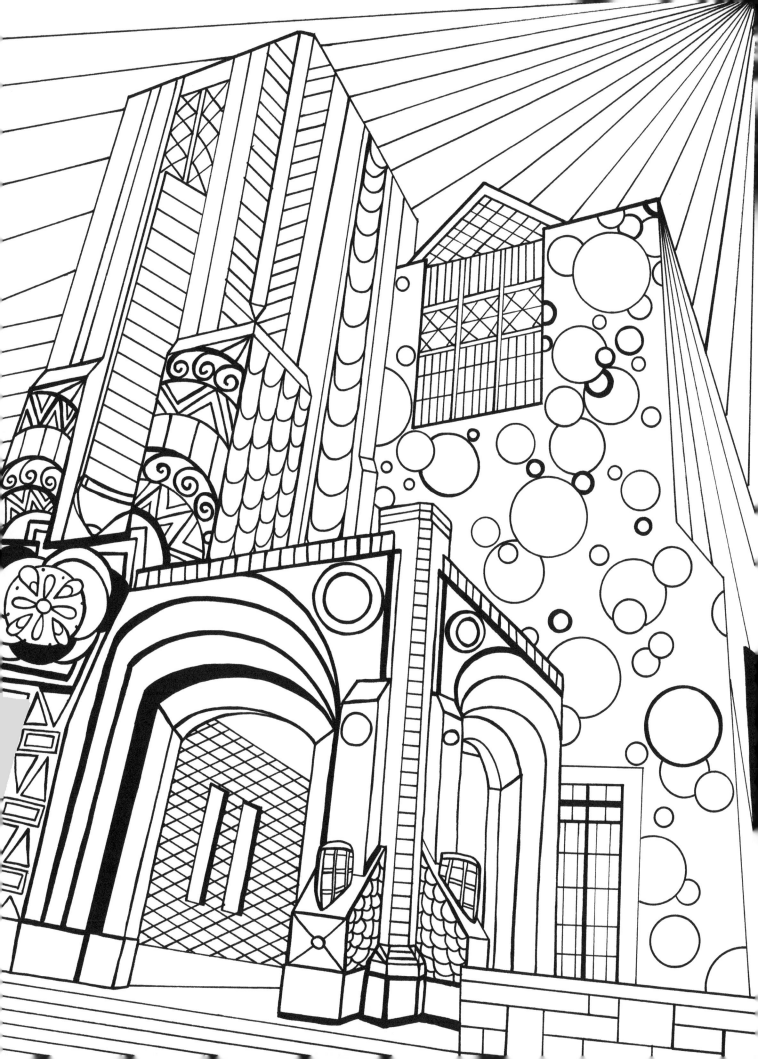

Kelley School of Business Hodge Hall Undergraduate Center

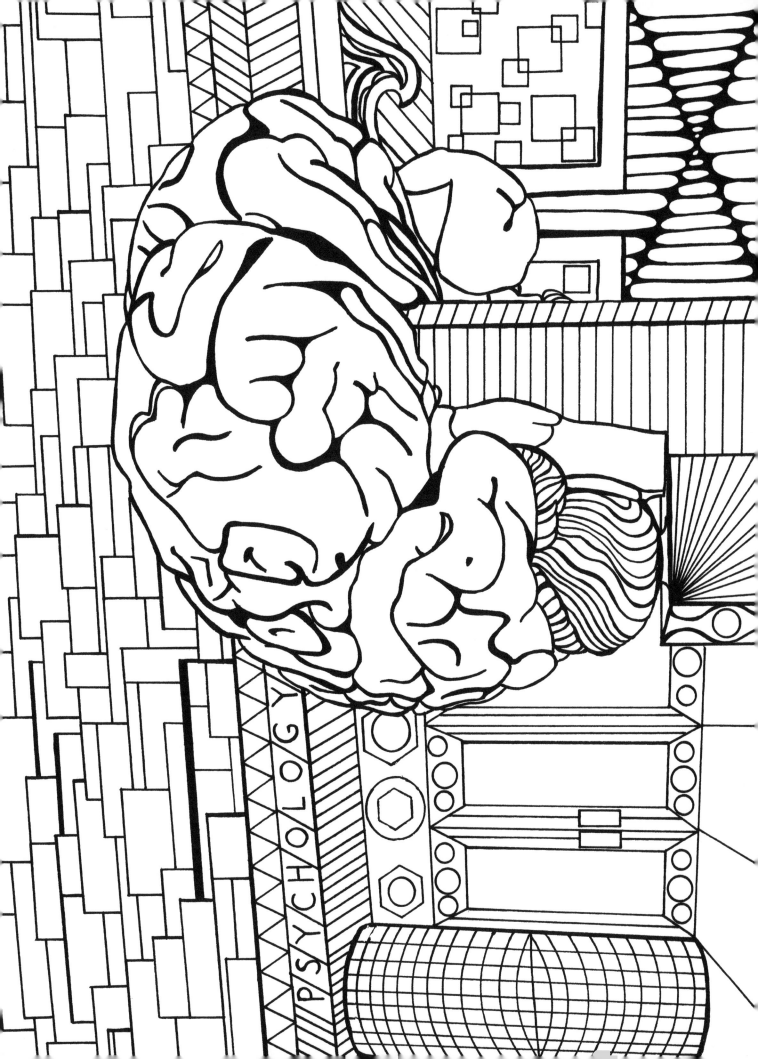

Department of Psychological & Brain Studies Building

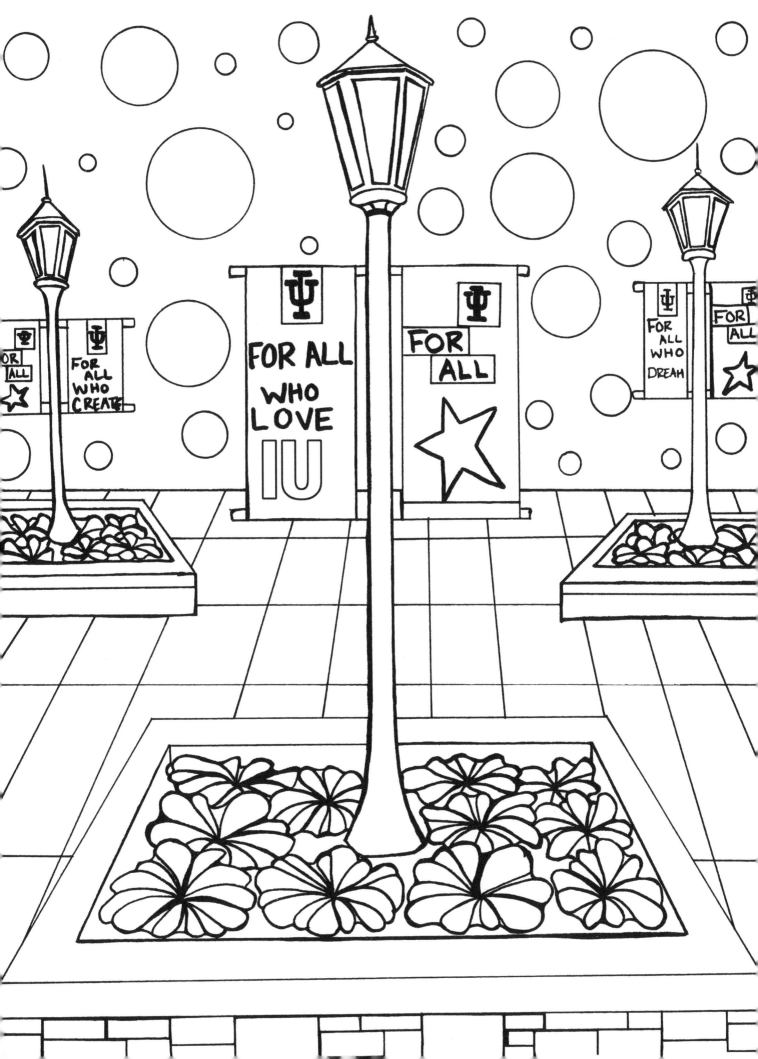

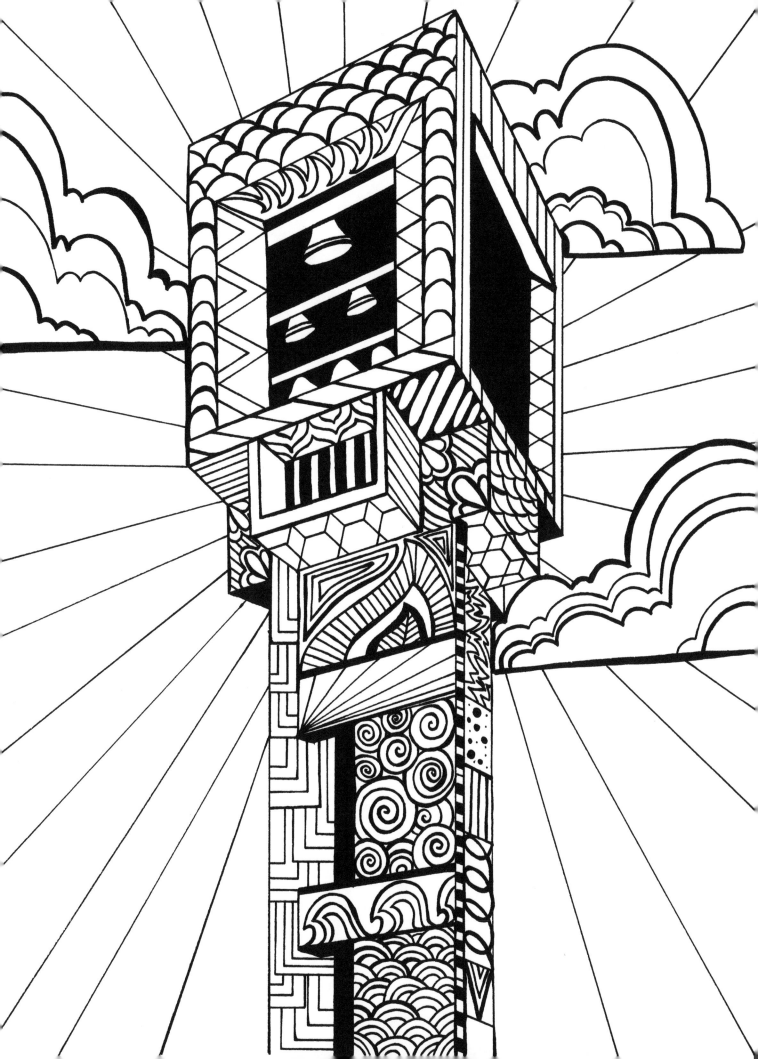

Arthur R. Metz Memorial Carillon

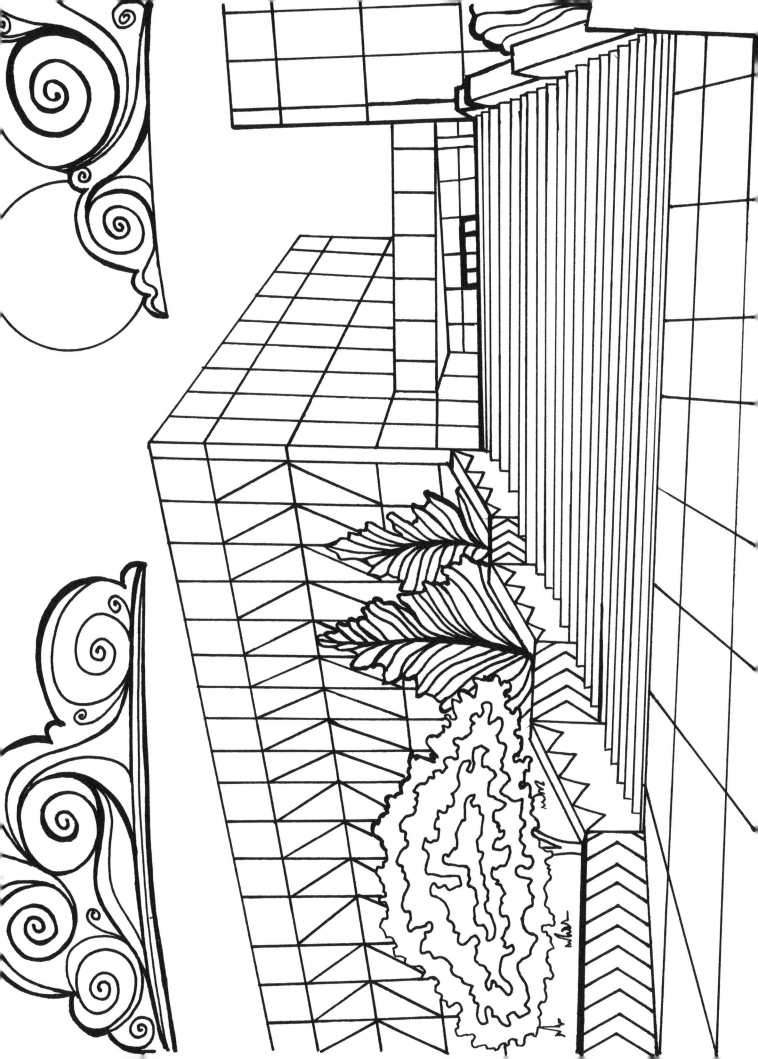

Student Recreational Sports Center

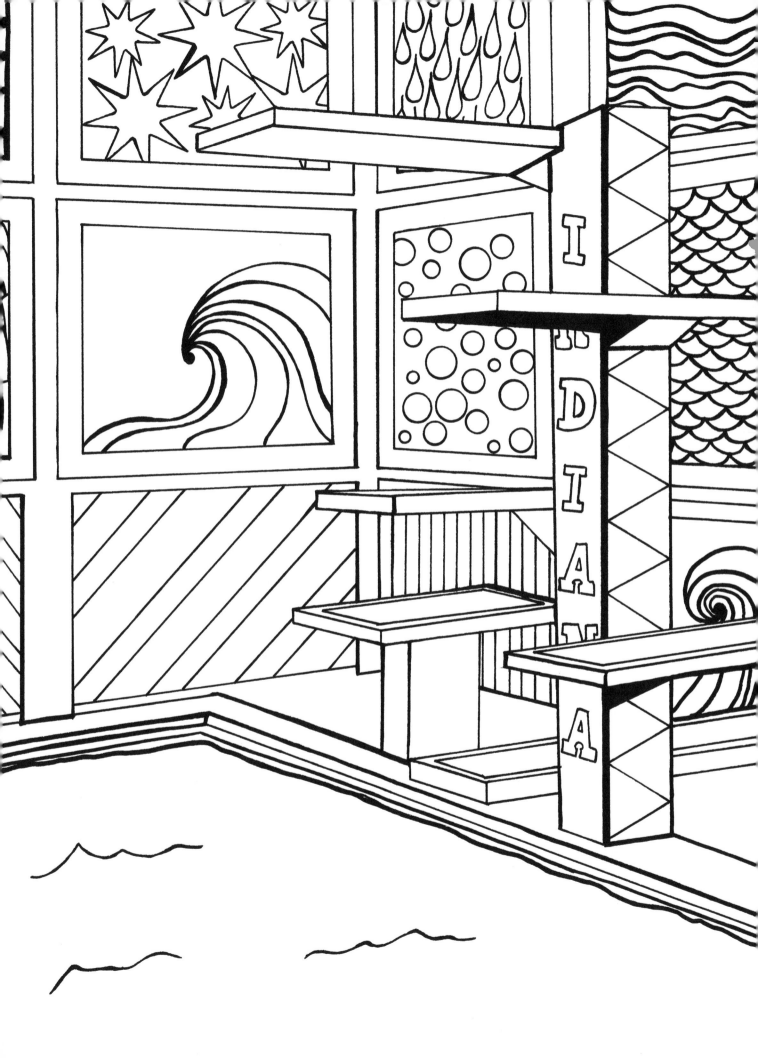

Counsilman/Billingsley Aquatic Center

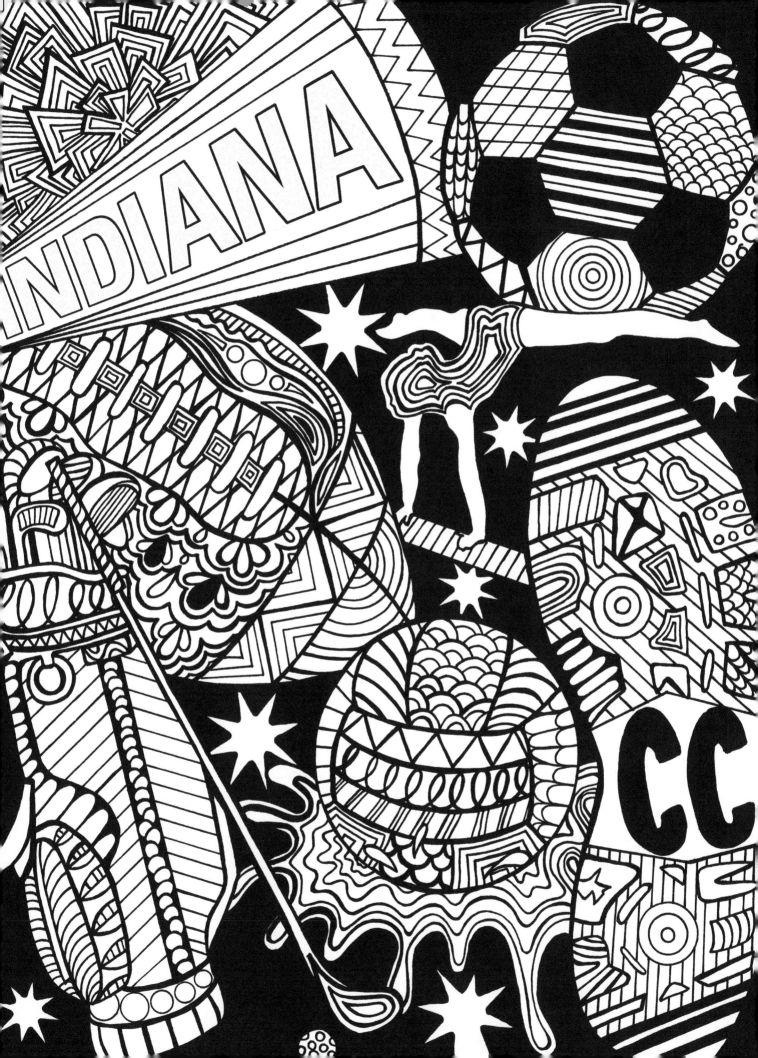

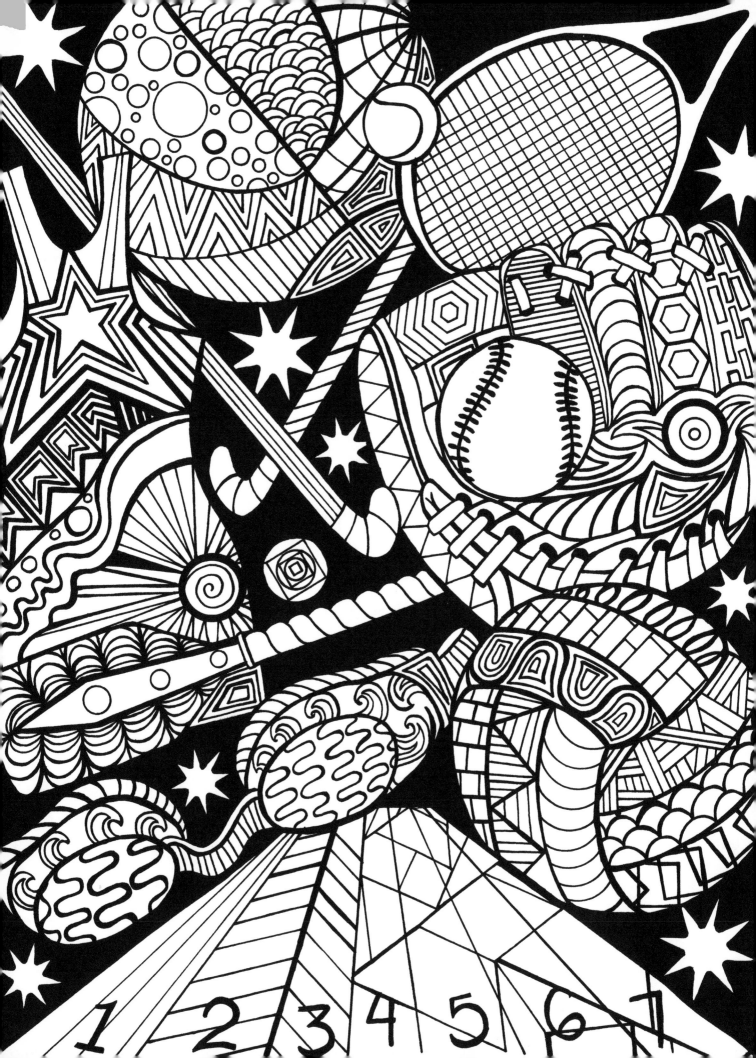

PRESS

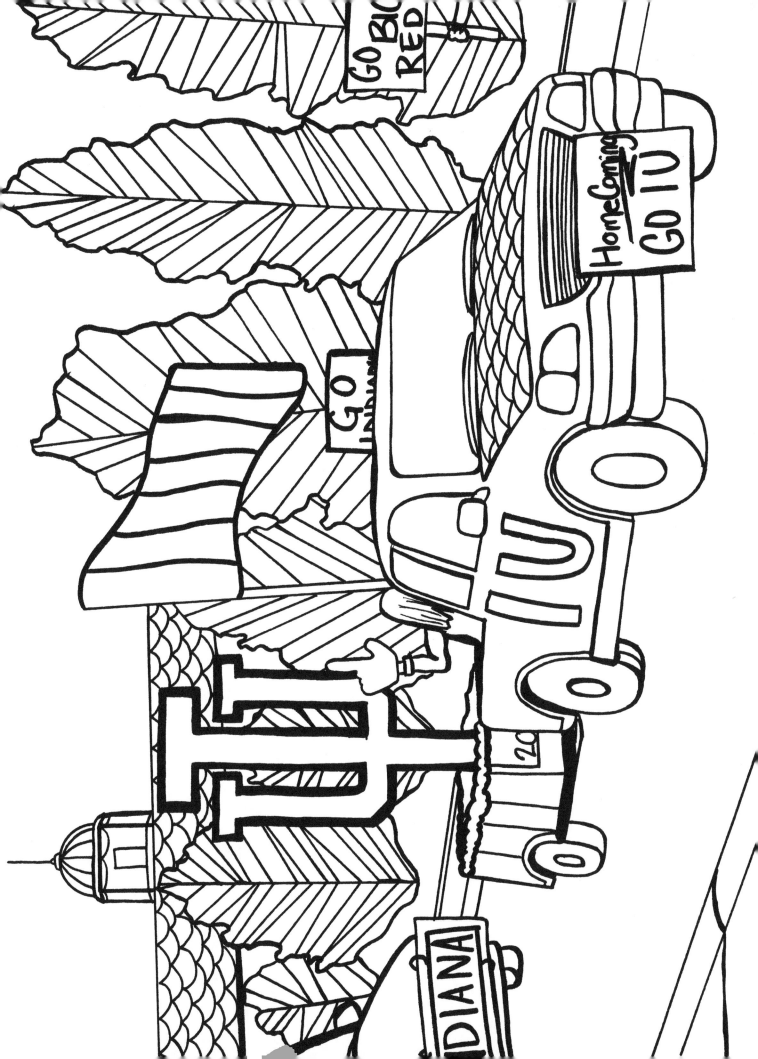

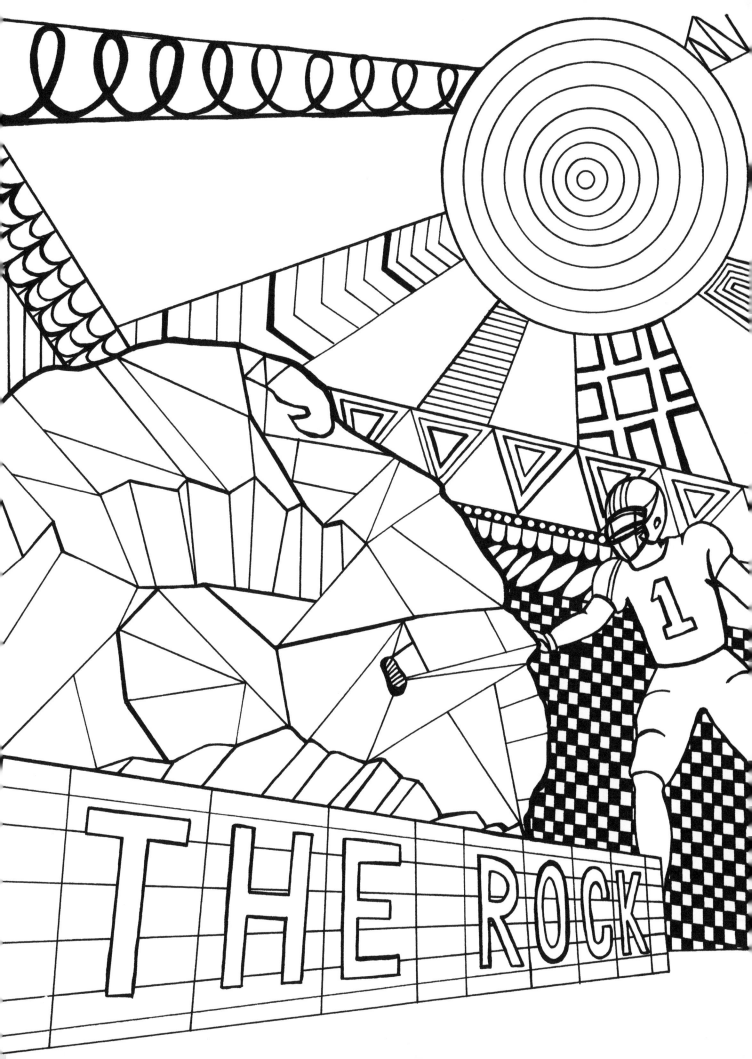

Memorial Stadium's The Rock

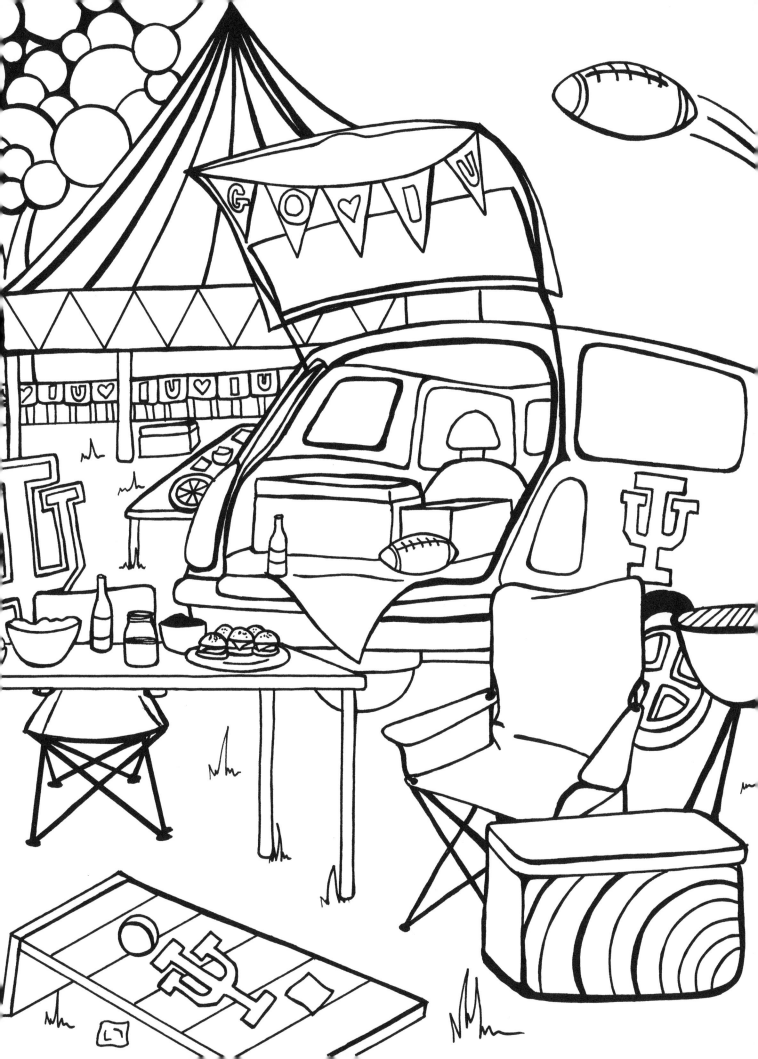

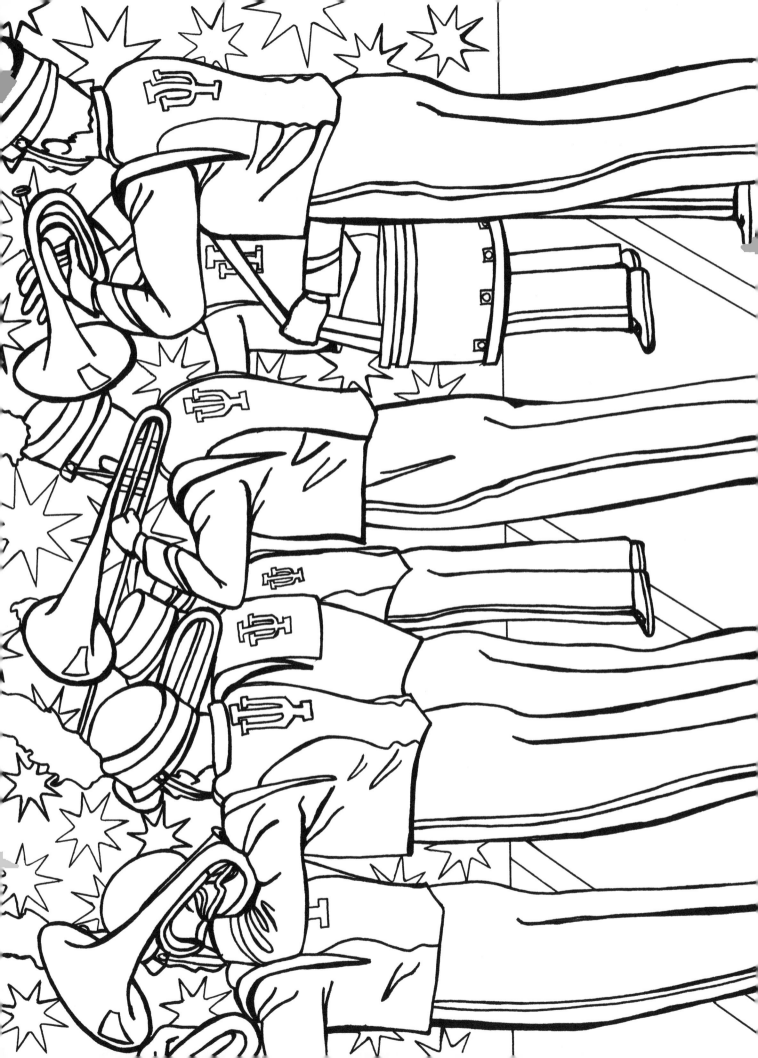

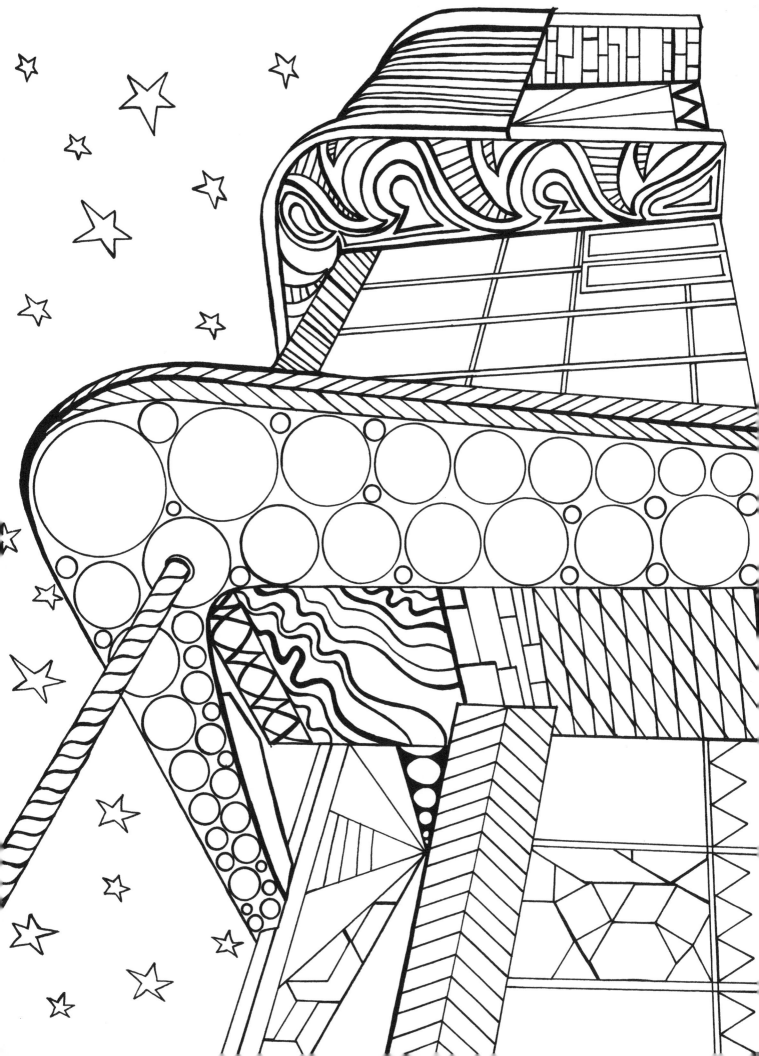

PRESS

Cook Hall

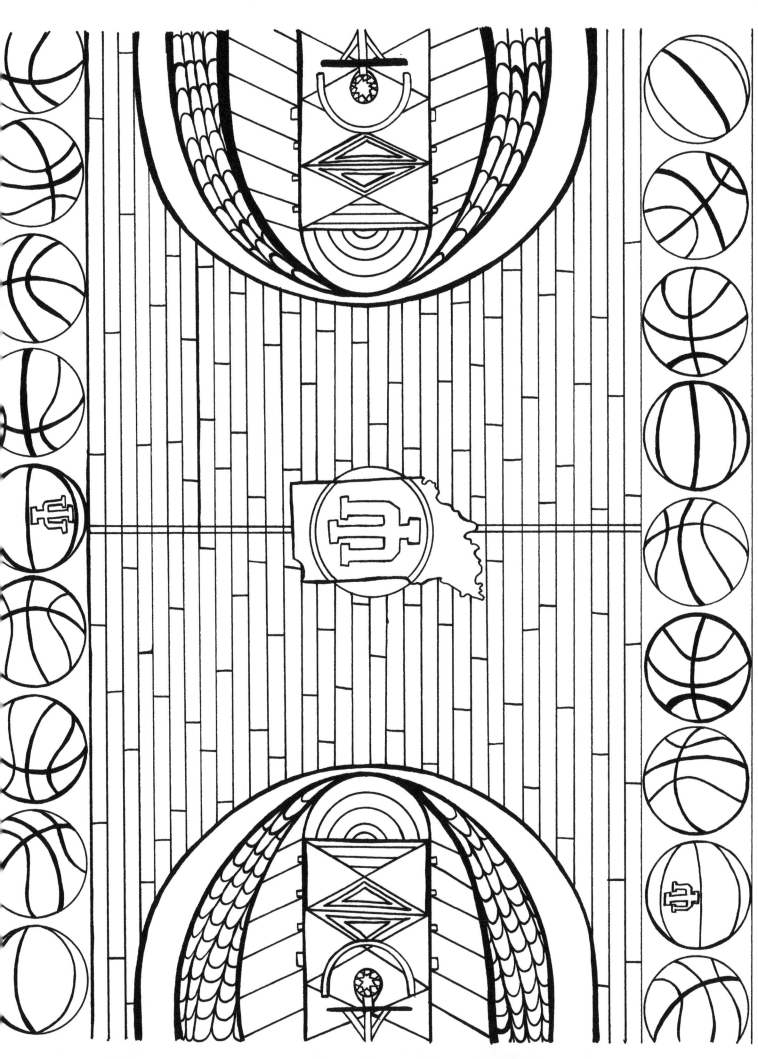

Assembly Hall court

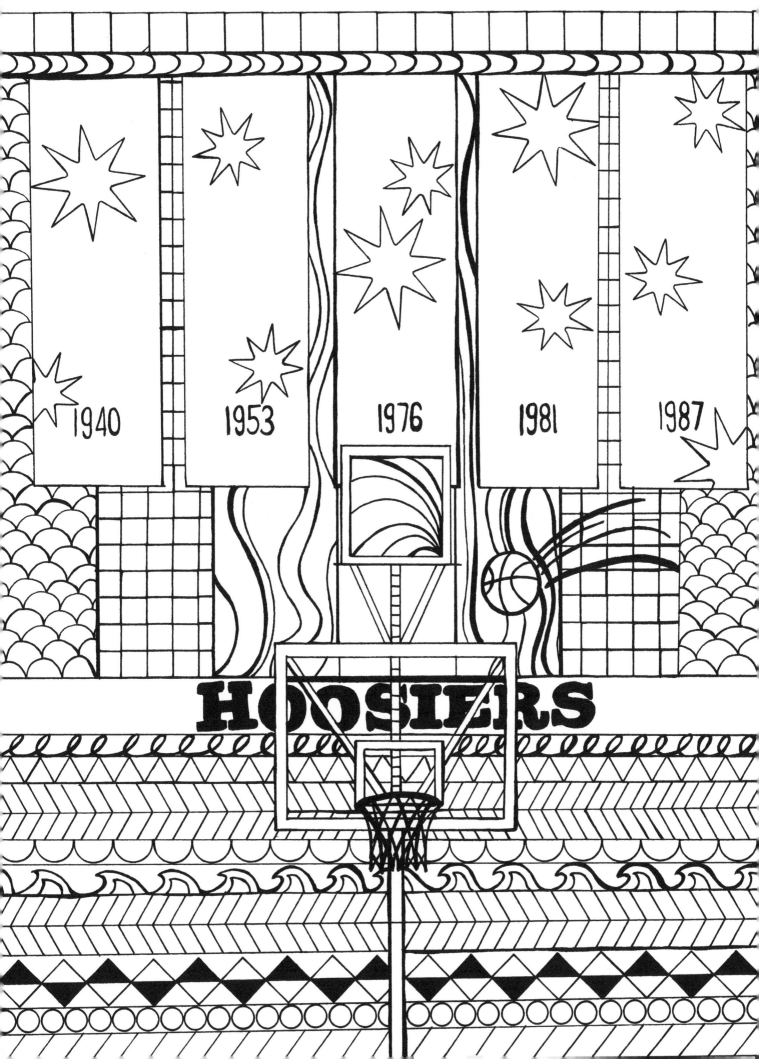

Assembly Hall banners

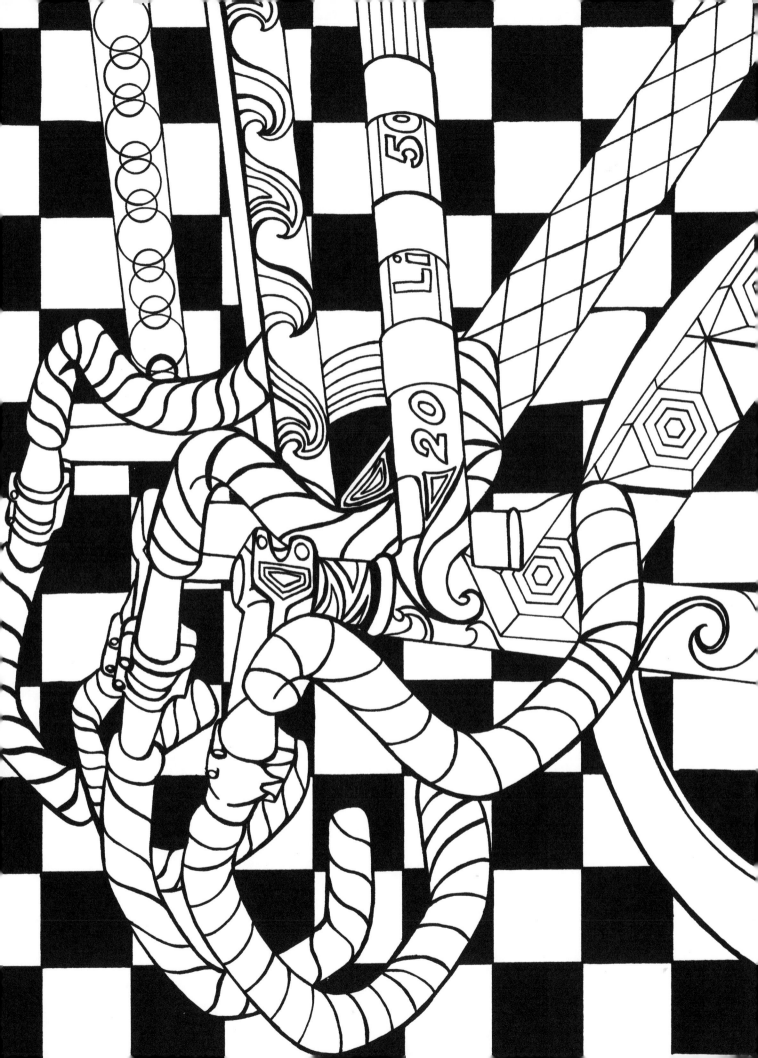

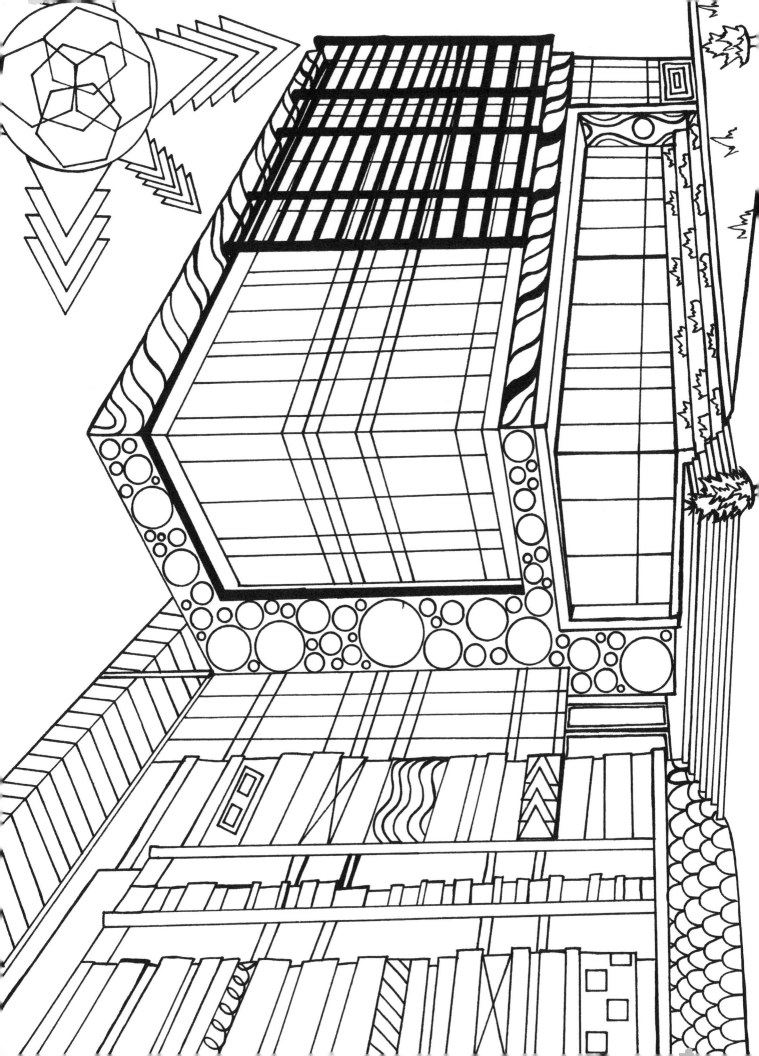

PRESS

Cyberinfrastructure Building

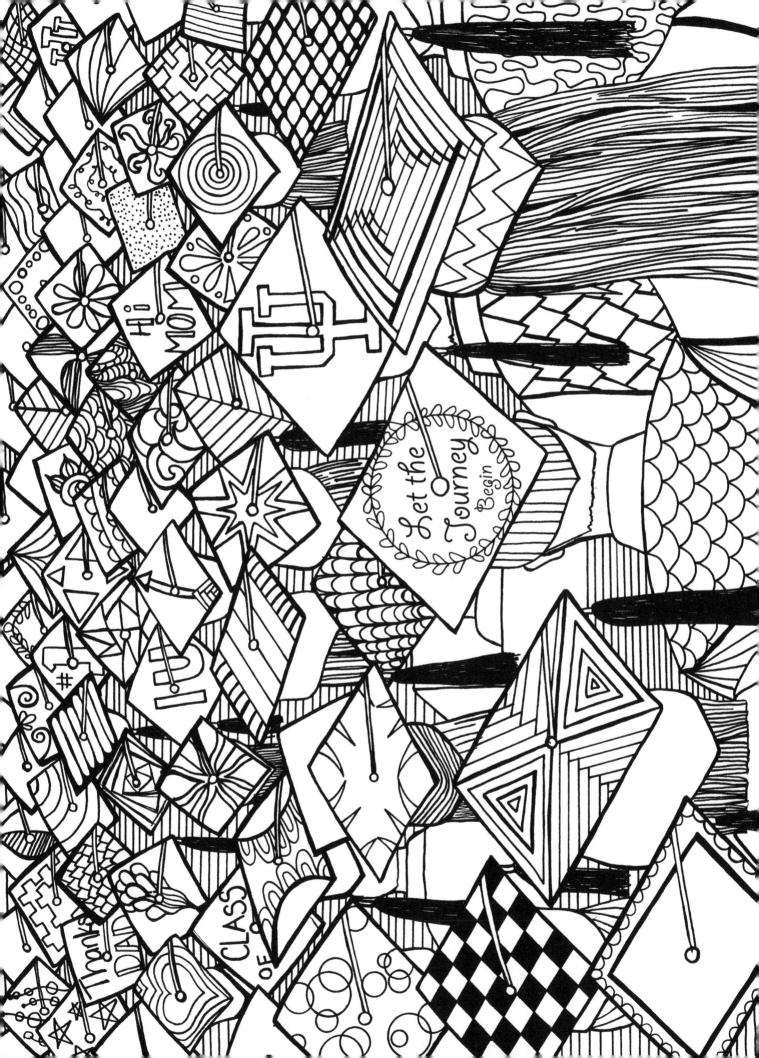

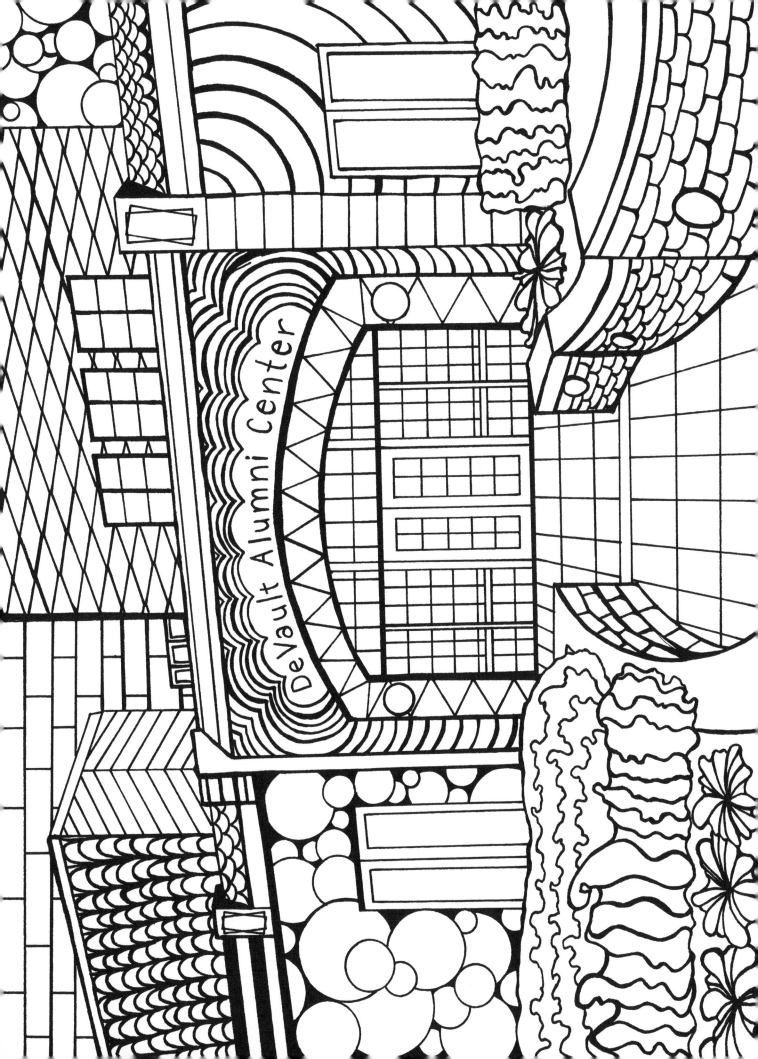